To: Don & Beth
with love.
Mom/Papa

I think Beth might enjoy
this book, too.

It would take chapters
to cover as much
of India's Indian history,
and Indian life
as is covered here.

Christmas,
2020

IN THE SHADOW OF THE RAJ

DERRY MOORE IN INDIA

IN THE SHADOW OF THE RAJ

DERRY MOORE IN INDIA

With a foreword by Mark Tully

PRESTEL

Munich · London · New York

TASVEER

To Alexandra

India is a curious place that still preserves
the past, religions, and its history.

No matter how modern India becomes,
it is still very much an old country.

Anita Desai

Contents

Editor's Preface

Nathaniel Gaskell

Derry Moore began photographing in India in the 1970s – an interesting era in the country's modern history, poised between its independence in 1947 and the onset of globalisation in the 1990s. Through his interiors and portraits, Moore wanted to capture a cultural fluidity that still existed at this time between colonial and Indian styles, as evidenced in the architecture, interiors, fashions and, even more subtly, in the very countenance and poise of the people. On subsequent trips to India throughout the 1980s and 1990s, such scenes became harder to find, with Moore likening his process of finding subjects to "fishing in an increasingly emptied sea." Today, these scenes have all but disappeared, and this forms the subject of a new foreword for this publication by Mark Tully, former bureau chief of the BBC in New Delhi, whose relationship with India spans over eighty years.

Although many successful efforts have been made by heritage organisations to restore some of the buildings featured in the photographs in this book, such as the Chowmahalla Palace in Hyderabad, Derry Moore's photographs have captured an era of aesthetics in India, the atmosphere of which has largely disappeared. His photographs also encourage questions as to how India should navigate its economic rise while not losing its visual heritage and culture. As the historian William Dalrymple notes, "this fast-emerging middle-class India is a country with its eyes fixed firmly on the future. Everywhere there is a profound hope that the country's growing international status will somehow compensate for a past often perceived as a long succession of invasions and defeats at the hands of foreign powers."[1] Whatever the answer for how India should move forward, Derry Moore's photographs give us a chance to reflect on what's largely being replaced.

[1] William Dalrymple, *The Last Mughal*, Penguin 2006.

Foreword

Mark Tully

Looking at Derry Moore's photographs, I feel nostalgic and profoundly sad. I feel nostalgic because they bring back to me the India I knew as a child, and the India I knew when I first came back to live here in 1965. I feel sad because so many Indians show so little respect for that past. India has one of the oldest, if not the oldest culture in the world; Varanasi is the only surviving ancient city which can claim its culture has not changed. This culture has survived because India has long adapted to the other cultures that have come with conquerors and settlers. Mahatma Gandhi famously said, "I want the culture of all lands to be blown about my house as freely as possible. But I refuse to be blown off my feet by any." This has been the philosophy that has guided India. Now though, I see India being blown off its feet by crass consumerism and militant materialism carried by the wind known as globalisation and the neo-liberal economics which come with it.

In describing the buildings of British India that he has photographed, Derry Moore speaks of a cultural osmosis, "of British and European architecture on Indian buildings, and of India and its climate, as well as its styles, on the British." In our present times there is no osmosis. For the most part, Indian architects are surrendering to the dictates of developers concerned only with maximising their profits from the land on which they are to build, or abiding by the styles prescribed

in Public Works Department manuals. These buildings take no account of Indian culture. They don't have to take account of climate because air conditioning now looks after that, so high ceilings have become a rarity. When I first came to Delhi, the electricity supply was too erratic to rely on air conditioning.

The tragedy, as the photographs of the buildings and interiors in this book show, is that India has magnificent traditions of fine architecture and design, but so little of those traditions have passed into modern Indian architecture. What is even sadder is that modern India has shown so little respect for its former architectural achievements. Inflated land prices are a feature of globalisation everywhere. In India, this has led to the profit that can be made from a piece of land taking precedence over the historical or architectural merit of the building standing on it.

The large amounts of money to be made out of developing land has led to the wholesale destruction of old buildings to make way for bog-standard flats, high-rise apartments, shops and offices. All Indian rivers are held to be sacred, but commercialism is so rampant that developers have even been allowed to trespass on a riverbed as prominent as the Yamuna, where it flows through the capital, Delhi. Governments have made no effort to stop this vandalism, even though the irreparable damage caused to British city and town centres in the 1960s stands as a dire warning against putting commercial interests ahead of conservation. The burden of defending India's architectural heritage now lies on the shoulders of NGOs like the gallant INTACH (The Indian National Trust for Art and Cultural Heritage), which initiated the campaign for the conservation of heritage.

Derry Moore's portraits illustrate India before the changes that have come over it with the spread of consumerism. Consumerism depends on inciting desire. Without desire there is no urge to consume. The Hindu Laws of Manu warn, "desire is never satisfied by the enjoyment of the objects of desire; it grows more and more as does the fire to which fuel is added." Consumerism aims to create the dissatisfaction of desires which are not fulfilled. You can see that dissatisfaction in aggressive, argumentative modern

India's tendency to take to the streets at the slightest provocation, the senseless violence of those protests, and the demand for rights to be recognised without any recognition of the obligations of duty. But look at the faces of the chowkidar in Lucknow **(Plate 82)** and the guard in Jaisalmer **(Plate 68)** in this book and you see a lack of dissatisfaction; India's tradition of accepting what life brings, rather than wanting more and more.

One portrait made me particularly nostalgic – the portrait of Indira Gandhi dressed as usual in a sari, doing India's traditions of textile design proud **(Plate 86)**. She made many mistakes and achieved much too, but I particularly remember her for her deep commitment to India's pluralist, multi-religious tradition, for which in the end she gave her life. In her last speech she reiterated that commitment by talking of the importance of unity and integrity, saying, "I shall continue to serve until my last breath and when I die, I can say, that every drop of my blood will invigorate India and strengthen it." The next day, she was assassinated by two of her bodyguards who were Sikhs, having ignored warnings that in the aftermath of the army attack on the Golden Temple in Amritsar, Sikhs were not to be trusted. Indira Gandhi had insisted that in her united India, all communities were to be trusted whatever their religion. I view with great concern the attempts that have been made, and are still being made, to undermine the pluralist tradition Indira Gandhi lived and died for.

Many will argue that I am moved by Derry Moore's photographs because I wallow in nostalgia for the Raj. I may well be criticised for ignoring so much which needed to change in India, and has been changed by the fierce wind of globalisation. There is an argument to say more needs to change. I accept all this, but I would still argue that it is in India's interests and nature to go forward by evolution rather than revolution, to meet challenges to its culture by osmosis rather than surrender, to respect the past and accept the value of tradition alongside the need to change, to reject the black-and-white view of history and so concede that the British Raj was not an entirely black period in her history. So I make no apologies for my nostalgia when I look at Derry Moore's moving photographs of an India that I feel is passing away with too little regret.

The Photographer in India

Derry Moore

My initial idea had been to photograph some of the places whose days, I knew, were numbered. In the event what fascinated me was not simply the places themselves but also the hybrid quality of many of the lesser buildings that had been constructed since the first arrival of the British in India. A cultural osmosis was clearly discernible, that of British and European architecture on Indian buildings, and that of India and its climate, as well as its styles, on the British. In the latter instance a grandeur and a sense of space, such as are rarely seen in Britain, were frequently the outcome: rooms were higher, windows larger, corridors wider, details more lavish; the porticoes of relatively humble houses might have been snatched from the front of the British Museum. The appearance of their inhabitants too surprised me. I had been expecting folkloric looks, whereas what I found was far more interesting – the look and atmosphere of another century.

Though I did not realise it at the time, a transformation was beginning to overtake India; a transformation effected not merely by political change, such as the revocation of the princes' rights and privileges, and thus the effective extinction of the princely states, but also by technological change. In 1976, the telephone still appeared to be in its infancy – to telephone from one part of Bombay to another could take the best part of a morning, and as for telephoning from, say, Gwalior to Lucknow, only an optimist would attempt it.

Inconvenient as this might be, it had the effect of making the country even vaster. Life was more unpredictable and more surprising, and that feeling of adventure which is such a vital feature of Kipling's writings could still be sensed. Television was barely known, its homogenising effects yet to come. Mass tourism, with its camp-follower banality, was also a virtual stranger. Anything imported was prohibitively expensive, and "handmade" was the rule rather than the exception. The motor car – and by 1976 there were effectively only two models, both quite humble, to choose from – was a luxury rather than a necessity. Moreover, since Independence the ethos of Indian politics had been socialism with a sympathetic tilt towards the Communism of the Soviet Union. This had created a veneer of progress beneath which a traditional way of life was carried on with no more than its customary inconveniences.

On my first visit I was extremely fortunate in the introductions I was given, particularly in Bombay and Hyderabad. It was the latter which evoked a feeling of entering another age. Hyderabad was a Muslim state, whose ruler, the Nizam, had in the early eighteenth century been the Mughal emperor's viceroy in the Deccan, until he established himself as an independent ruler. It was the largest princely state in India (an area the size of France) and before the Second World War, it had had its own coinage. In 1947, after Indian Independence, the seventh (and last ruling) Nizam attempted to retain Hyderabad's own independence from the Indian government with disastrous consequences. By 1976, the state was a shadow of what it had once been. However, it was still just possible to find traces of its former glory, albeit in poignant circumstances. A friend of mine was married at the time to the present Nizam and I was her guest, although neither she nor her husband were in residence during my visit. I was driven around in an enormous 1950s Cadillac accompanied by an ADC (aide-de-camp), a well-known nawab. One day I astonished him by announcing that I would like to go for a walk in the palace grounds; he evidently thought I was mad. Undeterred, I set off past saluting sentries into the thorny and rocky wilderness that constituted the palace grounds. After a couple of minutes I heard a crunch on the gravel behind me; it was the Cadillac, sent to follow me in case I became tired. I abandoned the walk.

Lucknow, the capital of the former princely state of Oudh was, like Hyderabad, Urdu-speaking. Both places had been large enough to have a nobility that was not directly related to the ruler, and both had a courtly tradition and had known a period of graceful and cultured life far removed from the twentieth century. Lucknow, in particular, had been renowned for its poetry, its music and its food. Nothing could have been further from the fanaticism and intolerance of Islamic fundamentalism. In Lucknow, I visited a house cared for by an elderly and highly distinguished-looking chowkidar, or watchman; he was, I discovered, a direct descendant of the last king of Oudh, who had been deposed by the British when they annexed the kingdom just prior to the Mutiny in 1857 **(Plate 82)**. In 1976, both Lucknow and Hyderabad were relatively contained and there was a definite point at which each city ended and open country began – in the case of Hyderabad a landscape littered with rocks reminiscent of the island of the Gogottes.

I visited Calcutta a year after my first journey to India, apprehensive of finding a city of the dead and the dying such as had been described with relish and righteous indignation by many a journalist. What I had not realised was that Bengal (of which Calcutta was the capital) had the finest tradition of literature and learning in the subcontinent. Nirad Chaudhuri describes how, as a child brought up in a remote village in Bengal, he was familiar with all of Shakespeare and with much of Dickens. I was taken to a theatre in Calcutta where a performance of Turgenev's play, *A Poor Gentleman,* was being given in Bengali. Not speaking a word of that language, I was fortunate to be accompanied by someone who could translate for me. The play was transposed to Bengal in the 1960s and was the most remarkable performance of a Russian play that I have ever seen, the similarity between life in nineteenth-century Russia and that in India prior to the 1970s being very marked. There were still landowners with dozens of servants and retainers, landowners who frequently had poor relations living with them. And there were an increasing number of Lopakhins waiting to cut down the cherry orchards.

Another surprise in Calcutta was its architecture: apart from the buildings of British India, there was a host of houses that had been built in the last century by wealthy Bengalis, nearly all crammed into the narrow streets of Calcutta. These buildings had gardens or large inner courtyards, or both, and generally boasted an assortment of columns and statuary. By 1977 all, except the Marble Palace (**Plates 28–32**), were in various states of advanced decay. In the absence of the rule of primogeniture they were shared by an ever-increasing number of descendants, none of whom were willing or able to accept financial responsibility for their upkeep and maintenance. In addition to this, the owners were frequently subjected to petty forms of persecution by government officials resentful of what they perceived to be relics of the bad old days. The Bengal climate, the enemy of plasterwork, paint and bricks, having been allowed to perform its work of destruction relatively unmolested, now seemed to pause and leave the buildings supported by their own decay.

While in Calcutta, a friend mentioned the city of Murshidabad on many occasions, until it assumed an almost mythical significance for me. In the eighteenth century, until the arrival of the British, Murshidabad had been the most important city in Bengal, the Nawab of Murshidabad enjoying the same status in the region as the Nizam of Hyderabad in the Deccan. The city is situated near Plassey, where in 1757 the British under Clive defeated the French and the forces of the Nawab of Murshidabad, Mir Jafar, in a battle that established the supremacy of the British in India. The railway never reached Murshidabad – a deliberate omission, according to my Calcuttan friend, calculated to destroy the city's importance. The journey which I eventually made involved a day's bumpy drive, at the end of which I reached a city which was a ghost of its former self. I found an assortment of palaces all in varying states of neglect and with little sign of habitation apart from the occasional watchman. One place, in particular, caught my attention. It was not that of the Nawab – indeed it did not appear to have a name – but had apparently been built by a Hindu grandee. Situated on the edge of a tank, or lake, and surrounded by palm trees, it was like a Renaissance palazzo uprooted and replanted in Bengal (**Plate 49**).

Madras, as a city, was a disappointment, for by 1976 it was already fast becoming an industrial centre. My visit was redeemed by an important introduction – to M. S. Subbulakshmi, the most famous singer in India, and her husband T. S. Sadasivam, a distinguished and devout Brahmin, who had been very close to the grandees of the Congress Party before Independence **(Plate 22)**. Subbulakshmi was to give a concert a few days later and both she and her husband were very keen that I should be there. Much as I wanted to attend, I was reluctant to spend four inactive days in Madras, and they therefore arranged for me to visit Madurai and Tanjore. Having recently come from the city of Hyderabad, where I had been amongst Muslims who were very much of the ancient regime, it was a shock to be plunged into an orthodox Hindu world.

The temple at Madurai **(Plates 24–25)**, according to Murray's handbook of 1973, is probably the most interesting Hindu shrine in India, giving one the most complete idea of Hindu ritual. Murray's recommendation that it should be visited at night as well as in the daytime, "the dark corridors with a lamp gleaming here and there being peculiarly ghostly", still applies. The temple, practically a self-contained world, is built in the shape of a parallelogram and contains a series of huge corridors and courtyards, those nearer to the centre being progressively more holy. In the outer corridors are vendors and shops **(plate 23)**, areas that seem to be practically dormitories for pilgrims, a stable for the temple elephant, and quarters for the priests. To me, it felt like walking into a temple in the Old Testament.

Of the places I visited in Rajasthan, the most interesting was probably Bikaner. It did not have the obvious attraction of, say, Jaipur or Udaipur, which so appealed to the tourist, but for that very reason it had remained relatively unaffected by the modern world. There were two curiosities which particularly caught my attention: one, the camel farm, and the other, a temple where rats are treated with love and respect – it is believed that the inhabitants of the city are reincarnated as rats – an interesting variation on the story of the Pied Piper.

It was in Bombay that I first heard the sound which evokes India more than any other – the cawing of the crows, the "dustmen" of India. In the daytime it is never absent, whether in town or country. It was in Bombay too that I first saw the houses that intrigued and surprised me so much. Built mainly in the nineteenth century and in the early years of the twentieth, they were European in style, but European with a difference, their walls a riot of decorative detail that eschewed any bare surface. The effect was not dissimilar to that achieved on Indian temples and temple carts. They displayed too those architectural features necessary to buildings in the tropics, in particular, the extravagant window surrounds designed to afford extra protection in the monsoon. In 1976, despite Bombay's move towards its incarnation as another Hong Kong, quite a number of these houses survived, and on Malabar Hill there were still a few of the great Parsi mansions standing.

The Parsi community more than any other has been responsible for Bombay's reputation as a city of tolerance, culture and humanity. Charity and good works are an intrinsic element of the Parsi religion and its fruits are manifest in Bombay – in hospitals, in the university, in art schools, in museums, in fact in everything that goes to make a city not just a place of employment and business but one of true civilisation as well. A glance at the section on Bombay in an old Murray guidebook will reveal to what extent this is true. Virtually every major institution in the city owes its existence to Parsi largesse.

With the immense increase in population that has taken place in Indian cities over the past fifty years, and with the huge influx of people from the countryside, the essence of the cities and that which gave them their individuality has been diluted, frequently to the point of invisibility. It was for this reason that I felt the urgency of recording what remained.

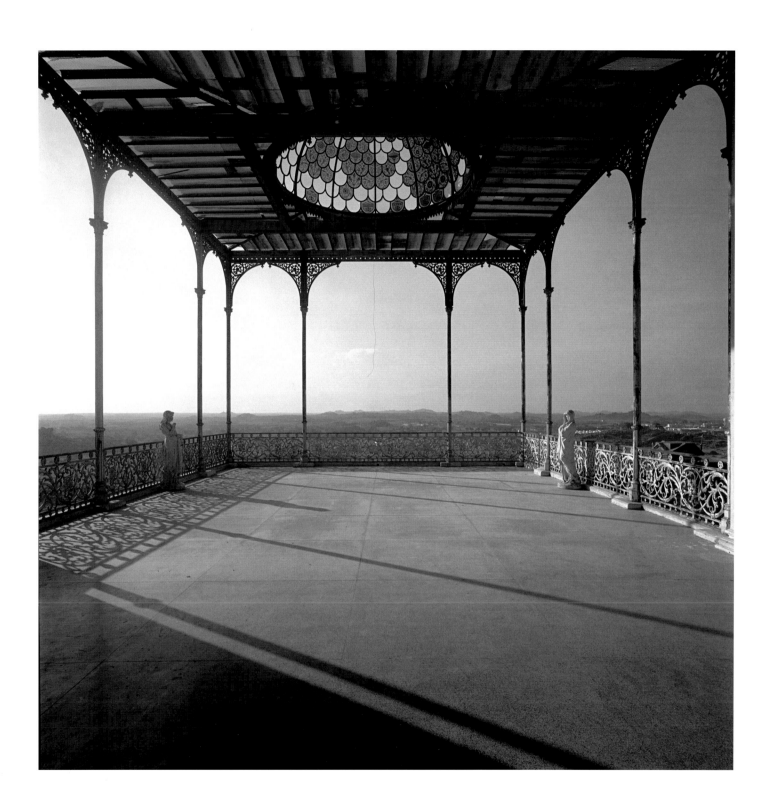

PLATE 1

Belvedere, rear end of the Falaknuma Palace,
Hyderabad, 1976

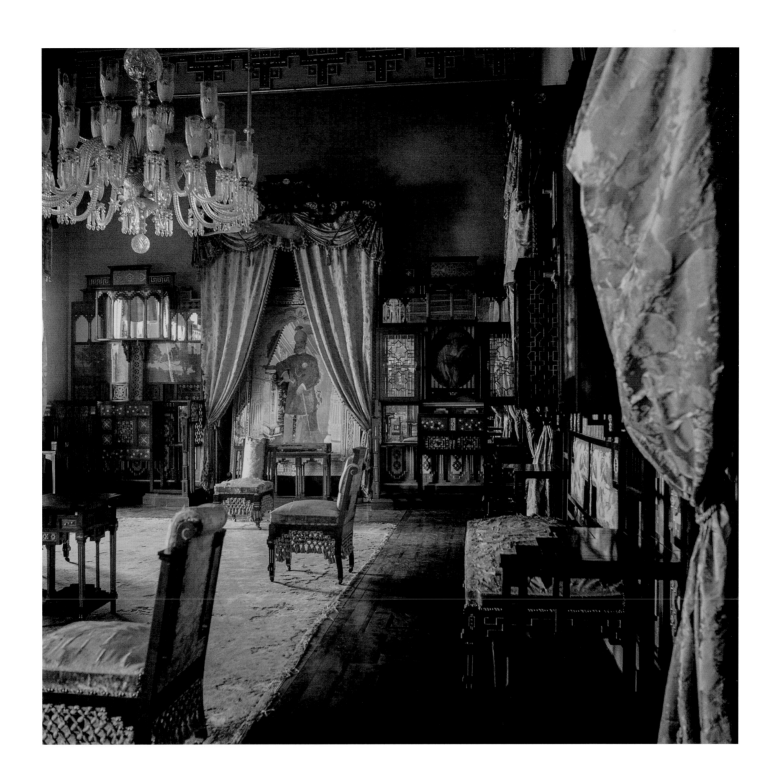

PLATE 2

Drawing room, Falaknuma Palace, Hyderabad, 1976

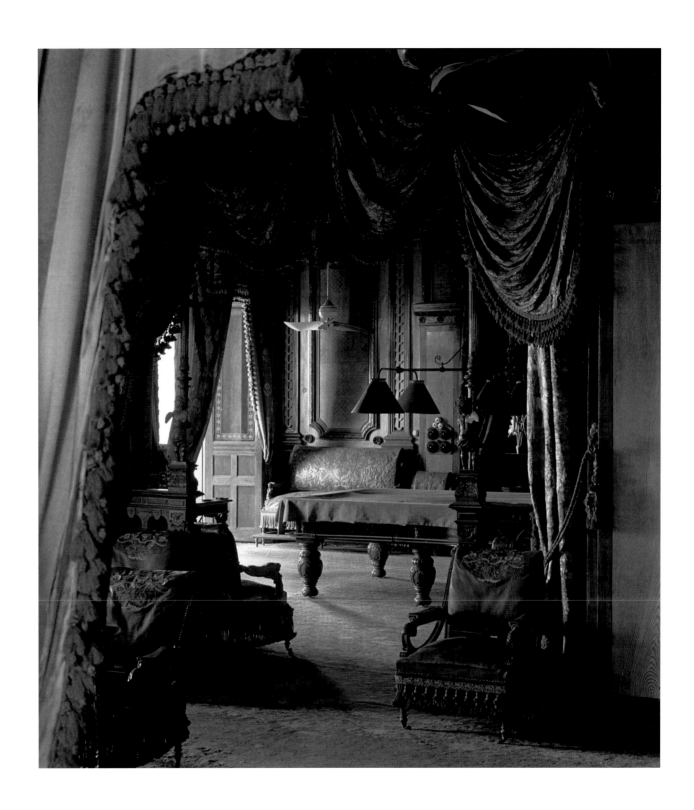

PLATE 3

Billiards room in the Gentlemen's Salon,
Falaknuma Palace, Hyderabad, 1976

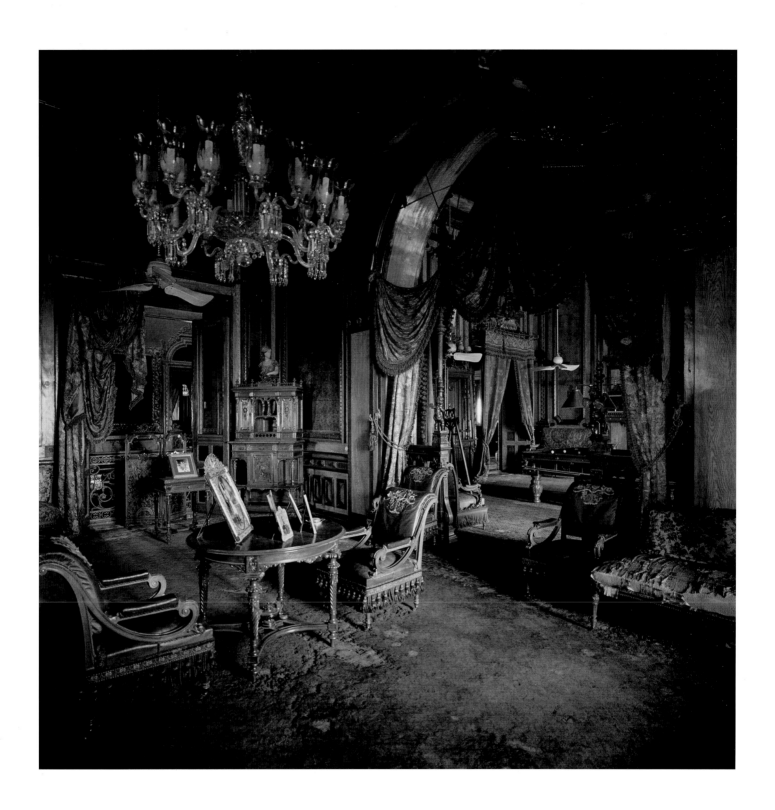

PLATE 4

Card room of the Gentlemen's Salon,
Falaknuma Palace, Hyderabad, 1976

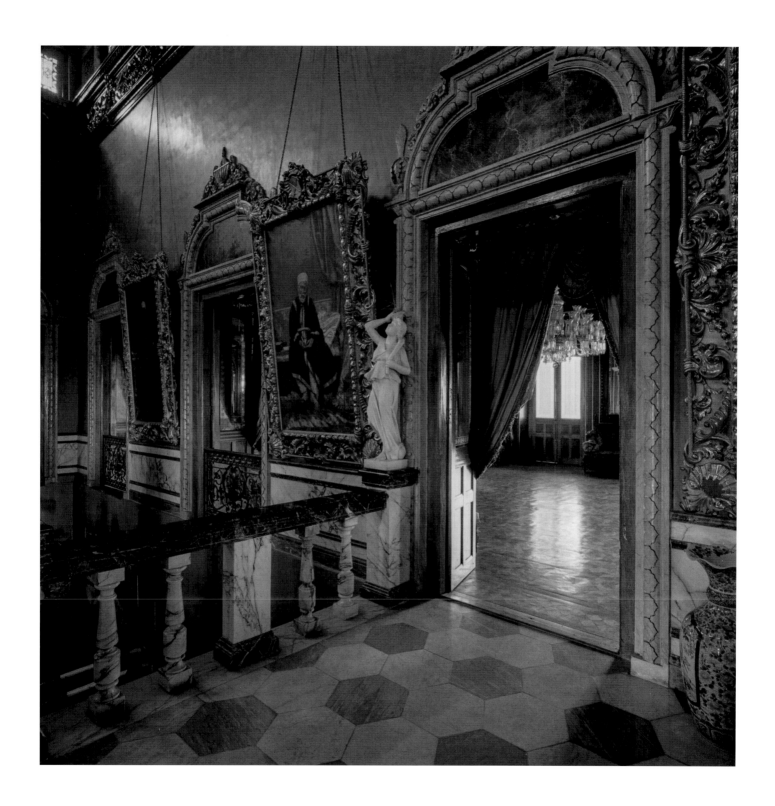

PLATE 5

The Grand Staircase, Falaknuma Palace,
Hyderabad, 1976

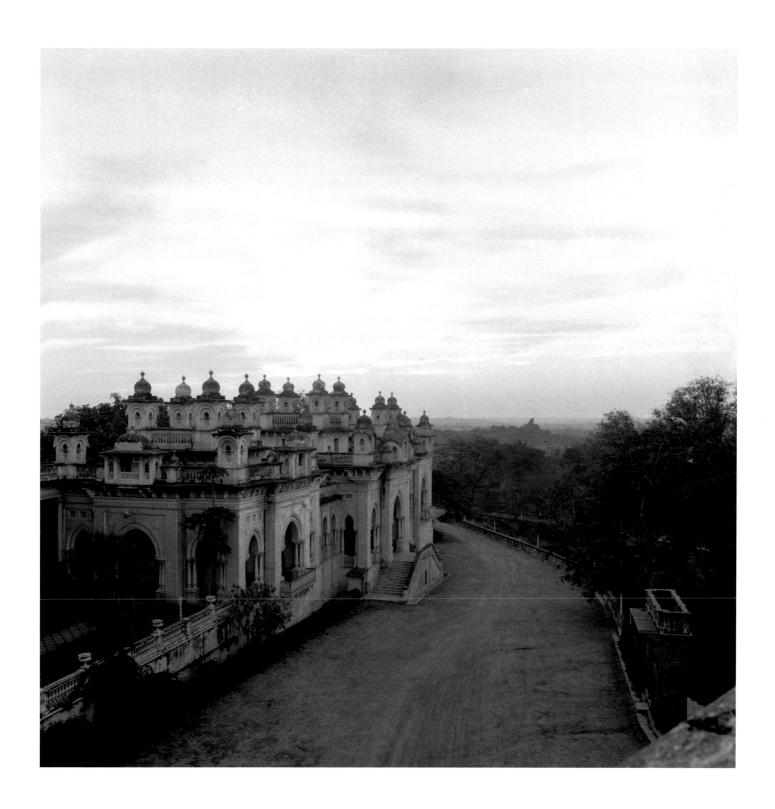

PLATE 6

Falaknuma Palace, Hyderabad, 1976

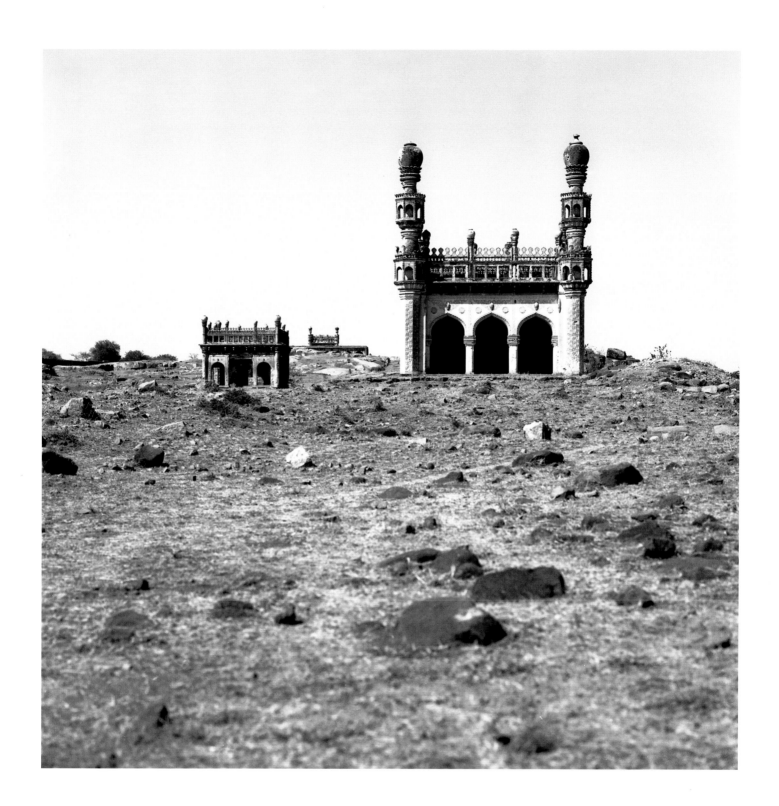

PLATE 7

Golconda Tombs I, Hyderabad, 1976

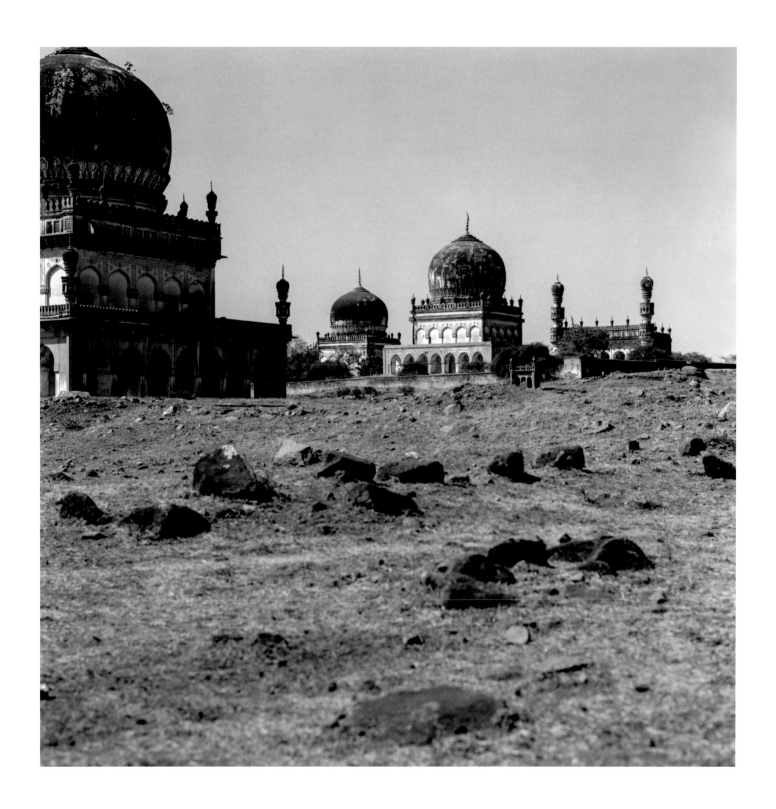

PLATE 8

Golconda Tombs II, Hyderabad, 1976

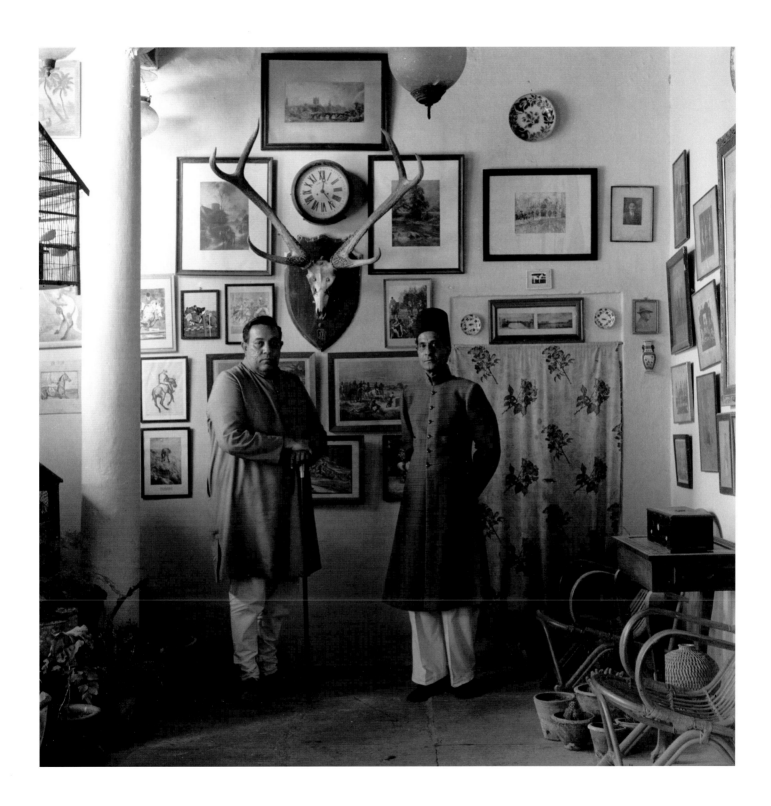

PLATE 9

Two Nawabs, Hyderabad, 1978

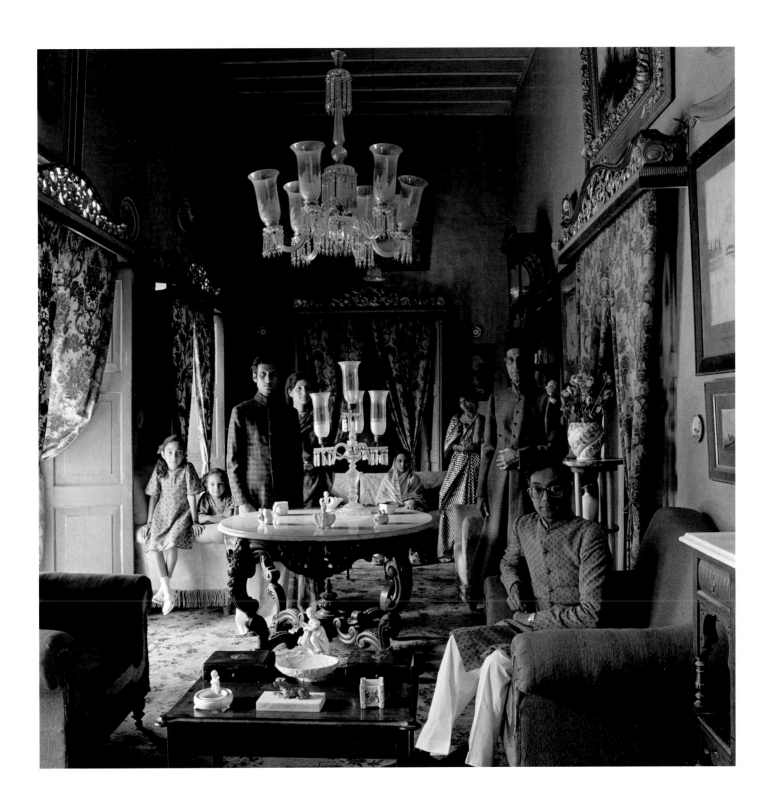

PLATE 10

Nawab Zainul Abedin Khan with his family,
Hyderabad, 1978

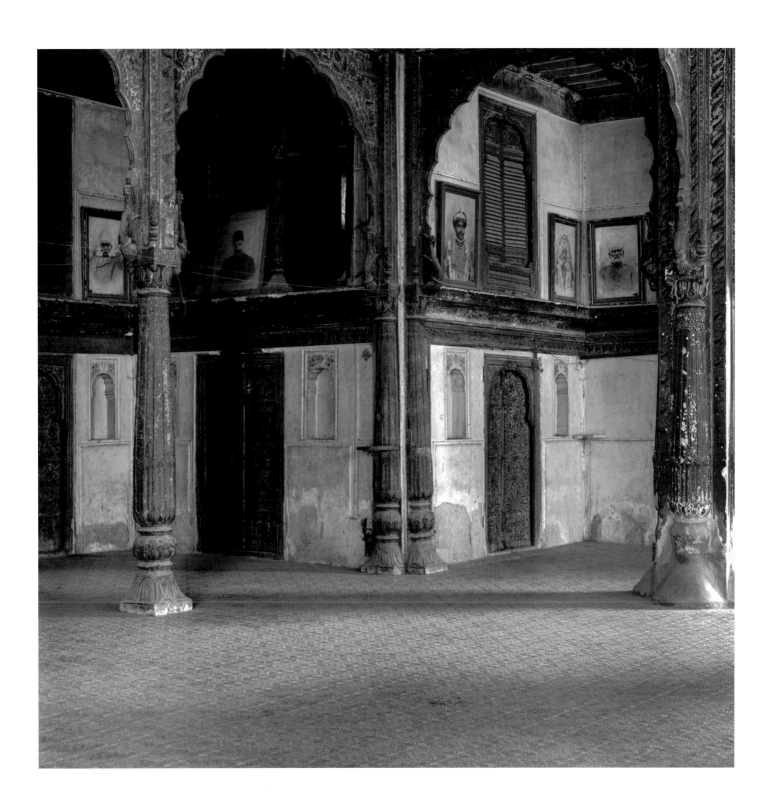

PLATE 11

Wall paintings, Hyderabad, 1976

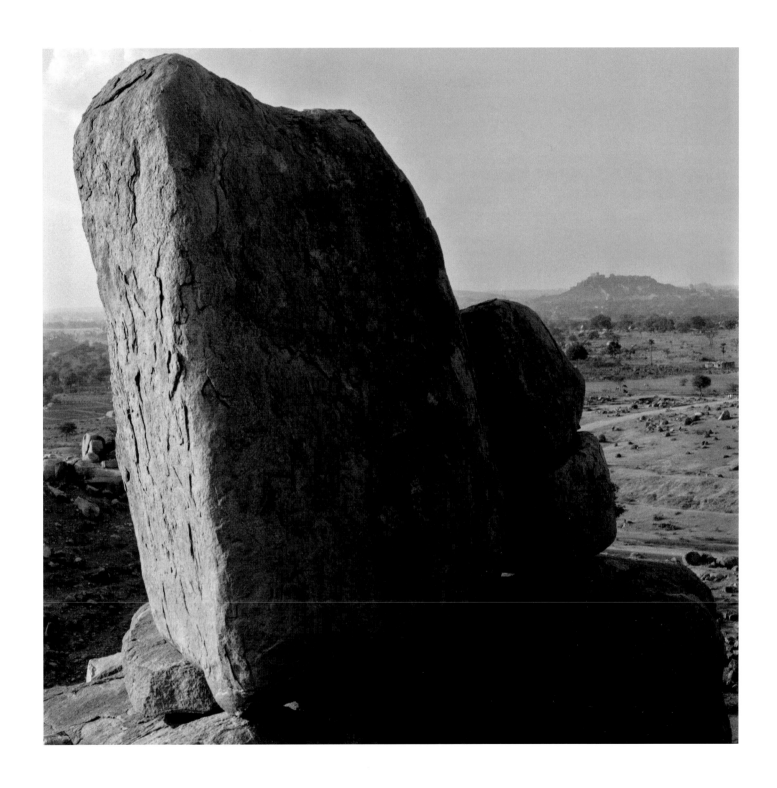

PLATE 12

Boulders, Hyderabad, 1978

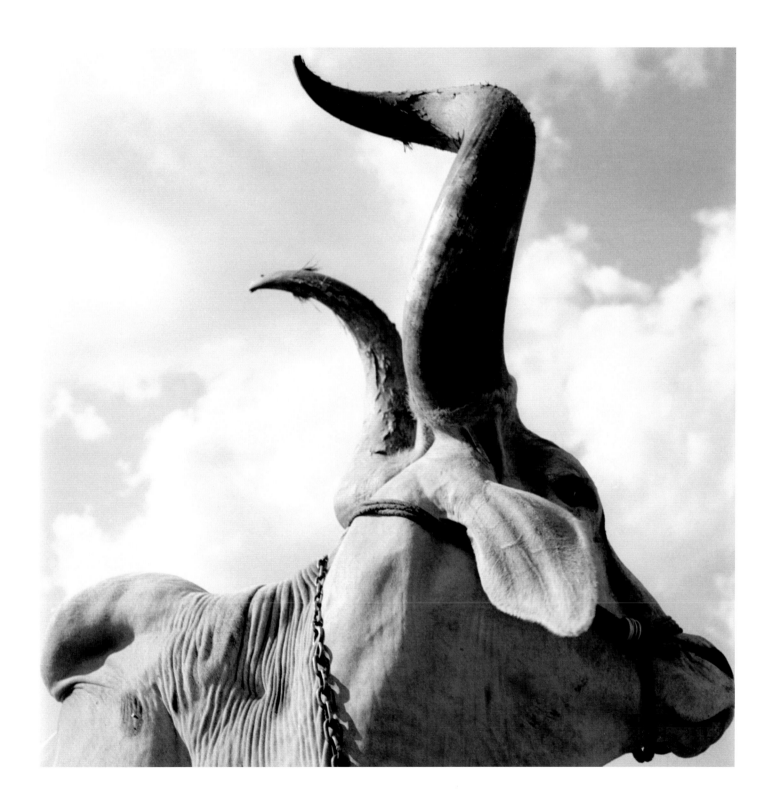

PLATE 13

A horned cow, 1976

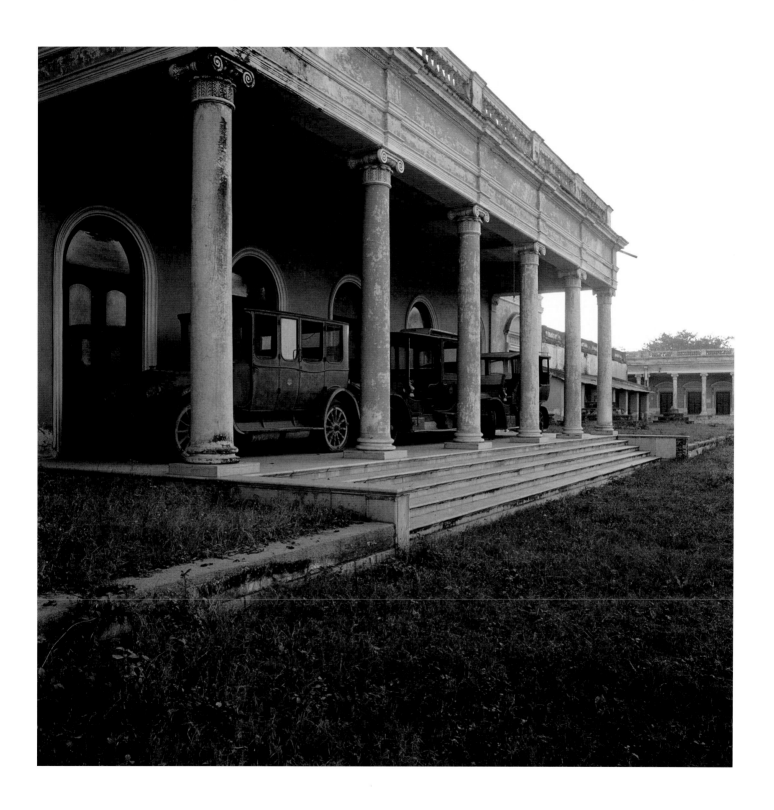

PLATE 14

Cars, Chowmahalla Palace, Hyderabad, 1976

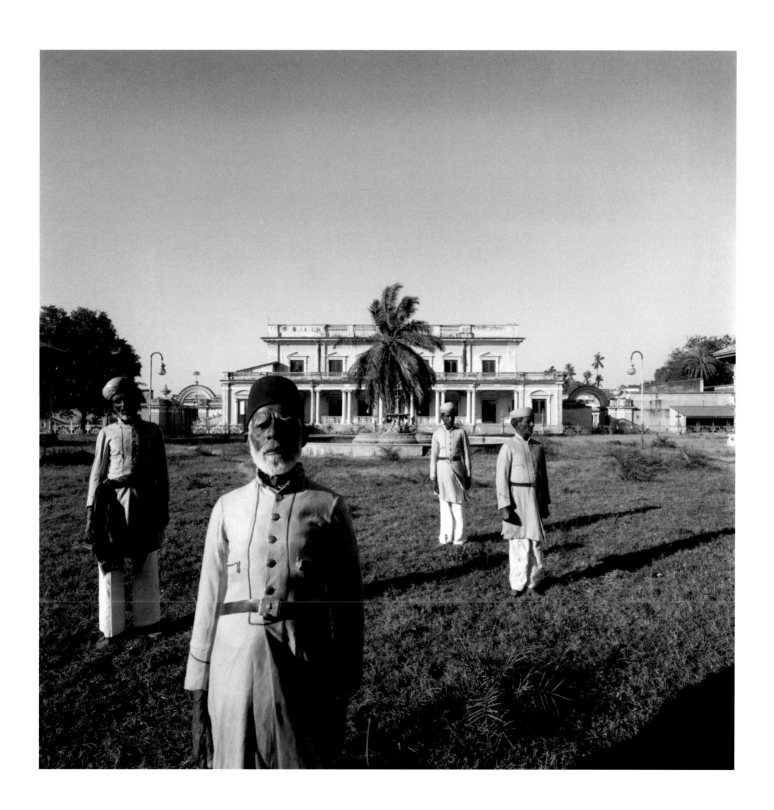

PLATE 15

Palace guards, Chowmahalla Palace, Hyderabad, 1976

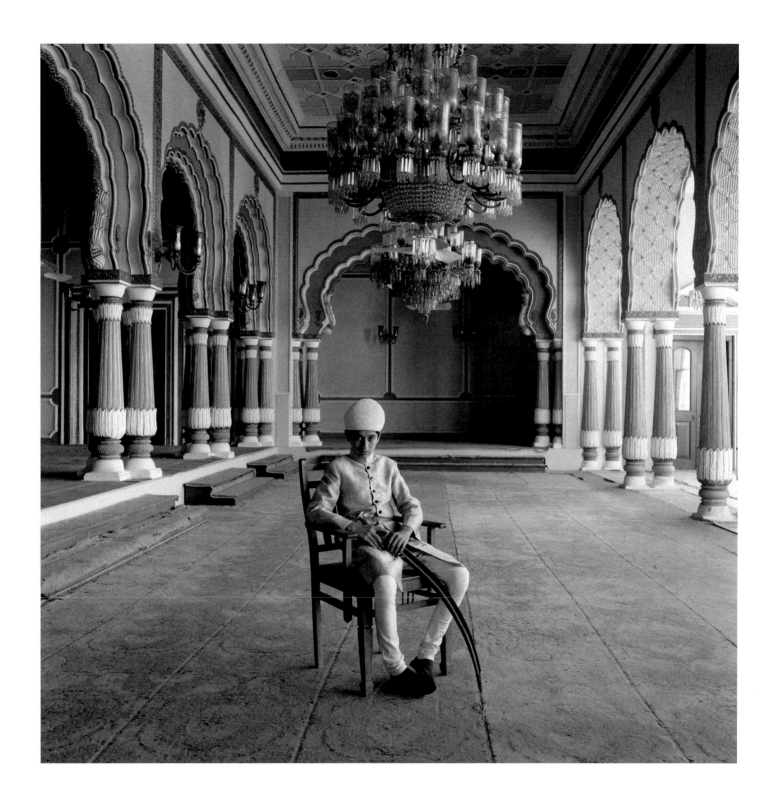

PLATE 16

Nawab's son, Chowmahalla Palace, Hyderabad, 1976

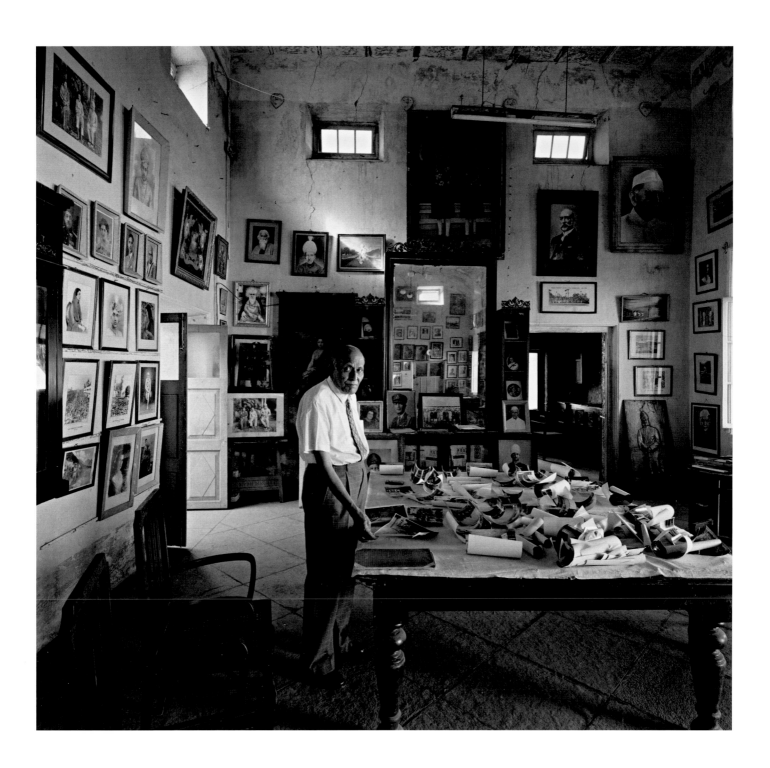

PLATE 17

Amichand Deen Dayal, grandson of Raja Deen Dayal,
in the studio, Secunderabad, 1978

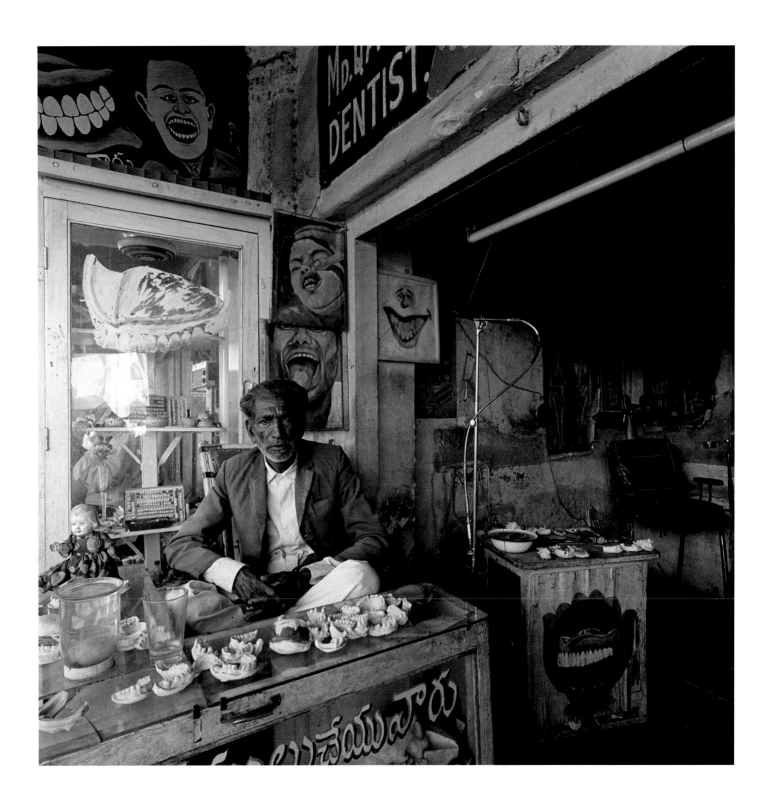

PLATE 18

Dentist, Hyderabad, 1978

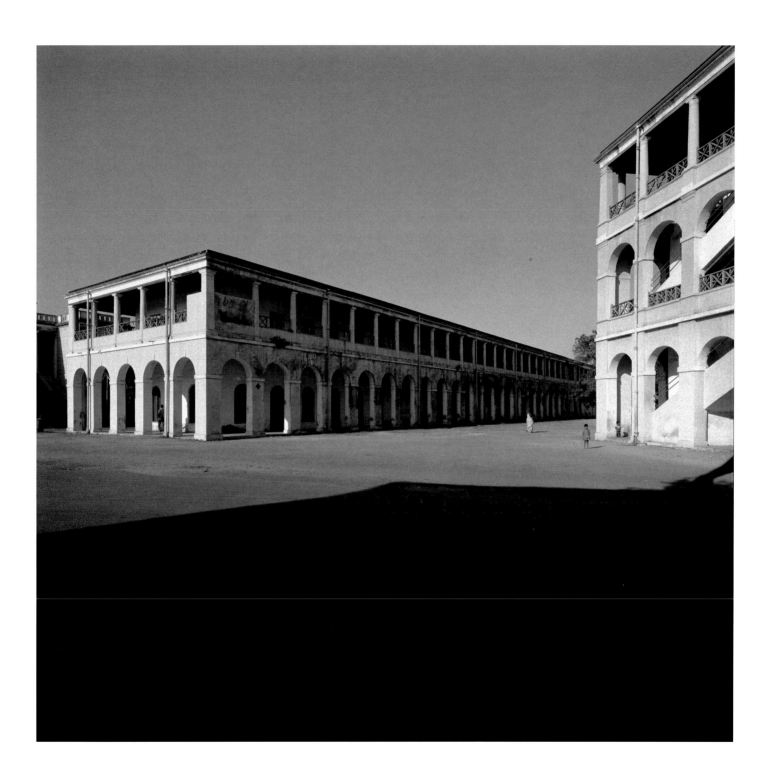

PLATE 19

Fort St George, Madras, 1976

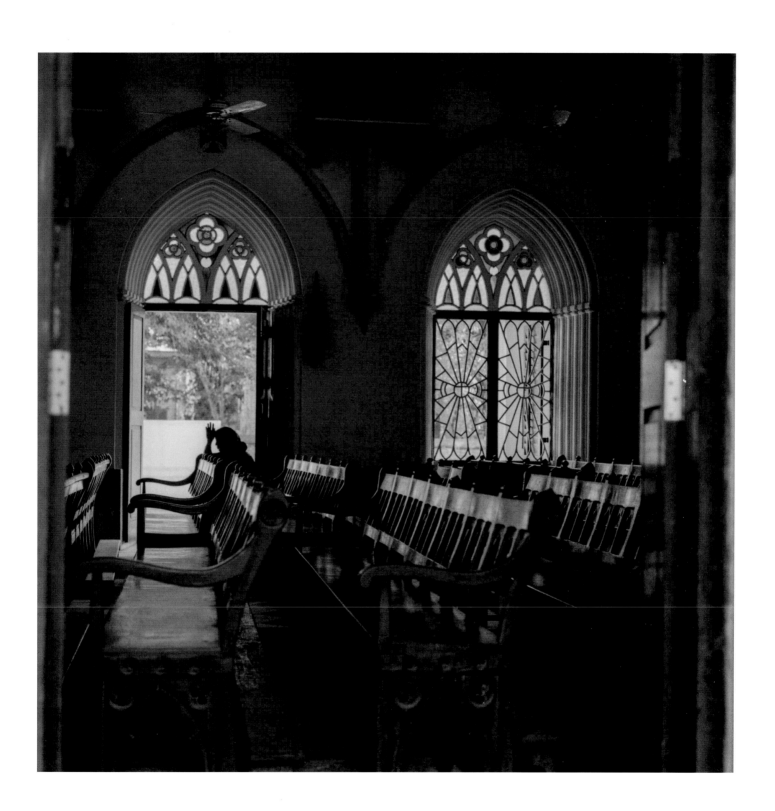

PLATE 20

Interior, Theosophical Society, Madras, 1976

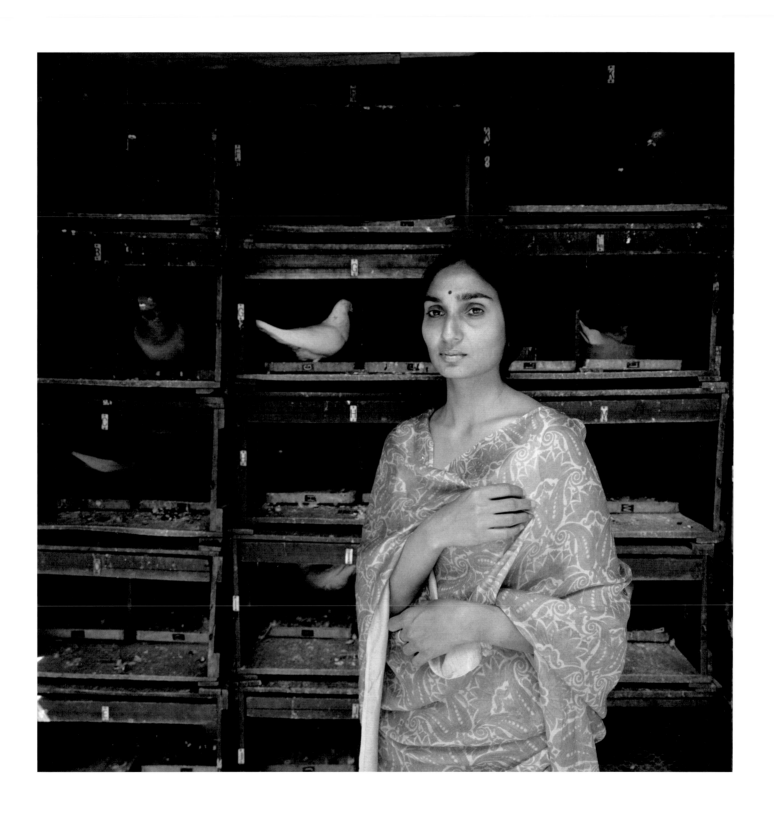

PLATE 21

Amrita Patel, 1976

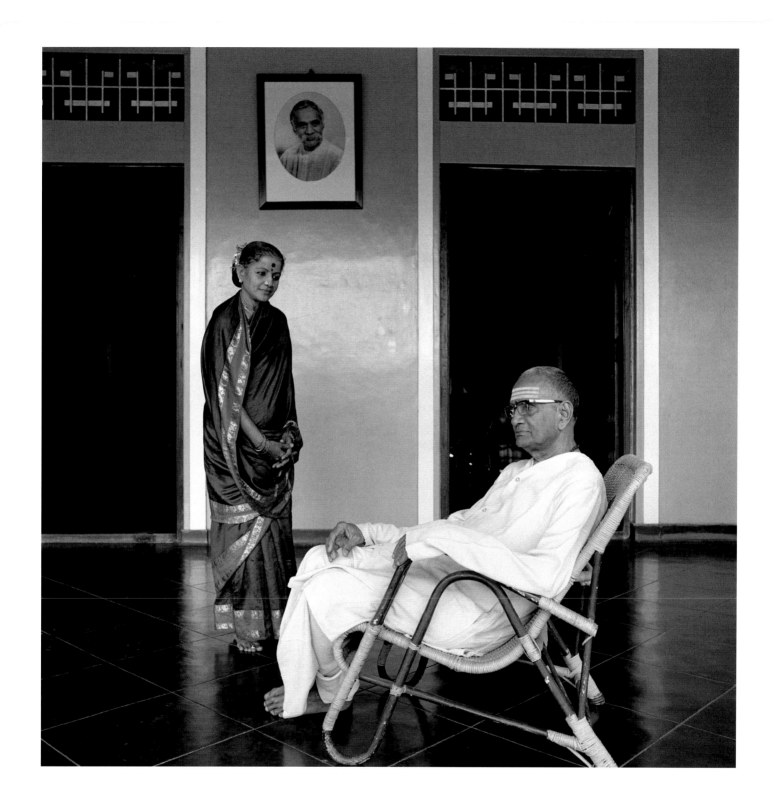

PLATE 22

M. S. Subbulakshmi with her husband
T. S. Sadasivam, Madras, 1976

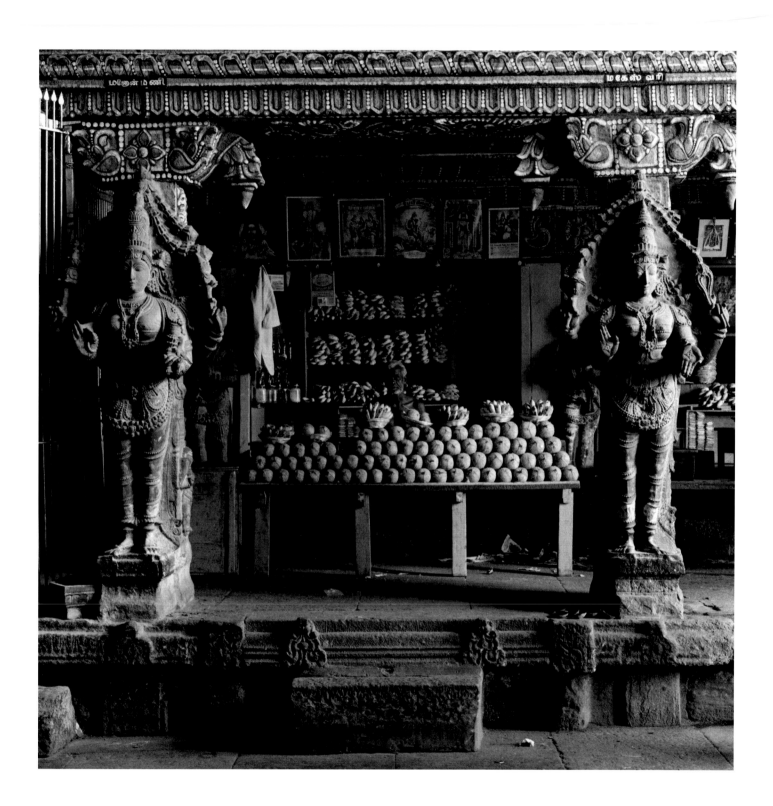

PLATE 23

Fruit stall, Meenakshi Amman Temple, Madurai, 1976

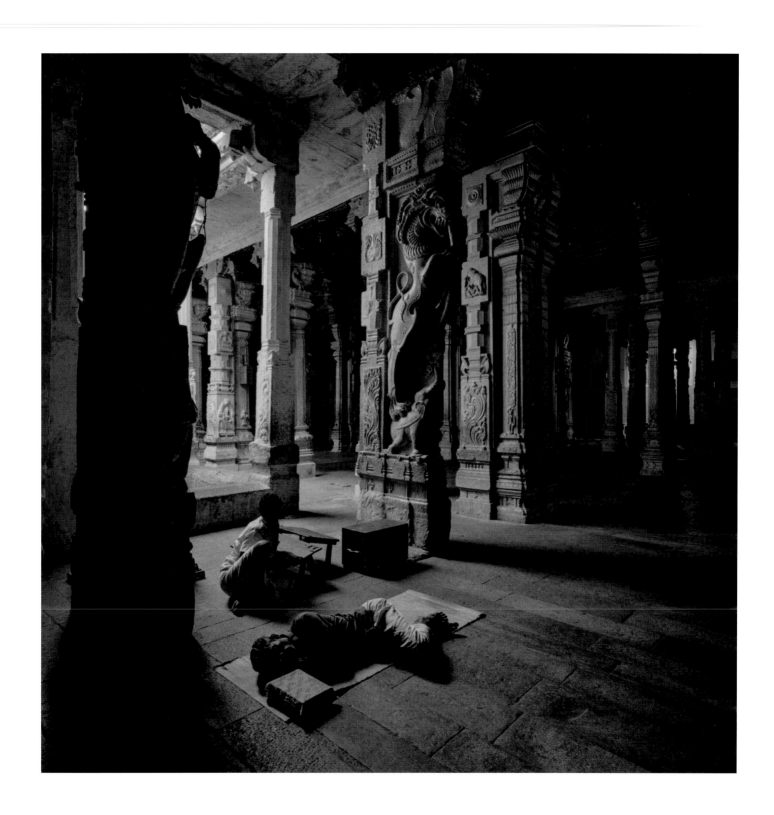

PLATE 24

Men resting in the Aayiram Kaal Mandapam I,
Meenakshi Amman Temple, Madurai, 1976

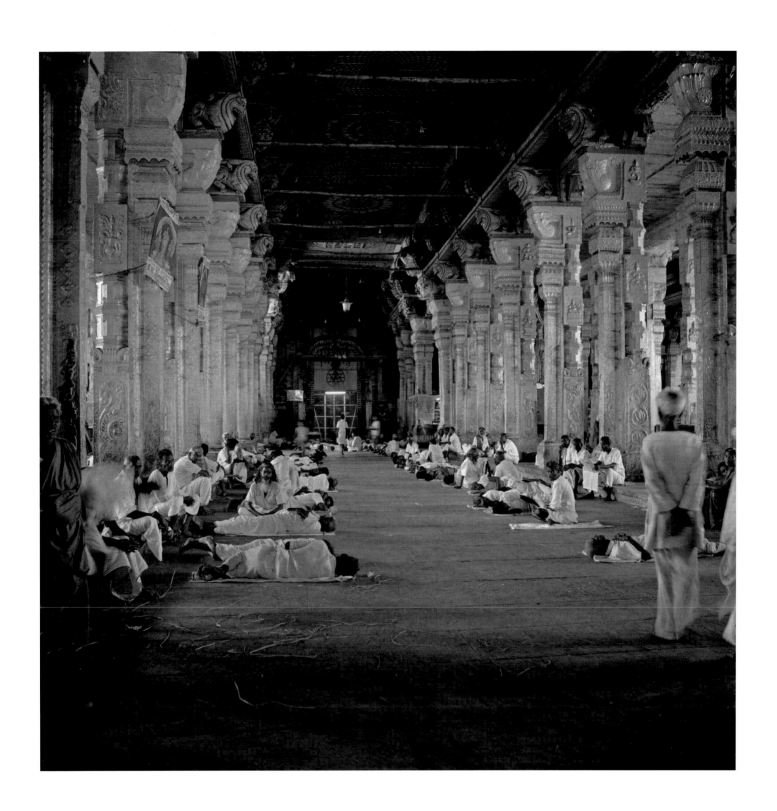

PLATE 25

Men resting in the Aayiram Kaal Mandapam II,
Meenakshi Amman Temple, Madurai, 1976

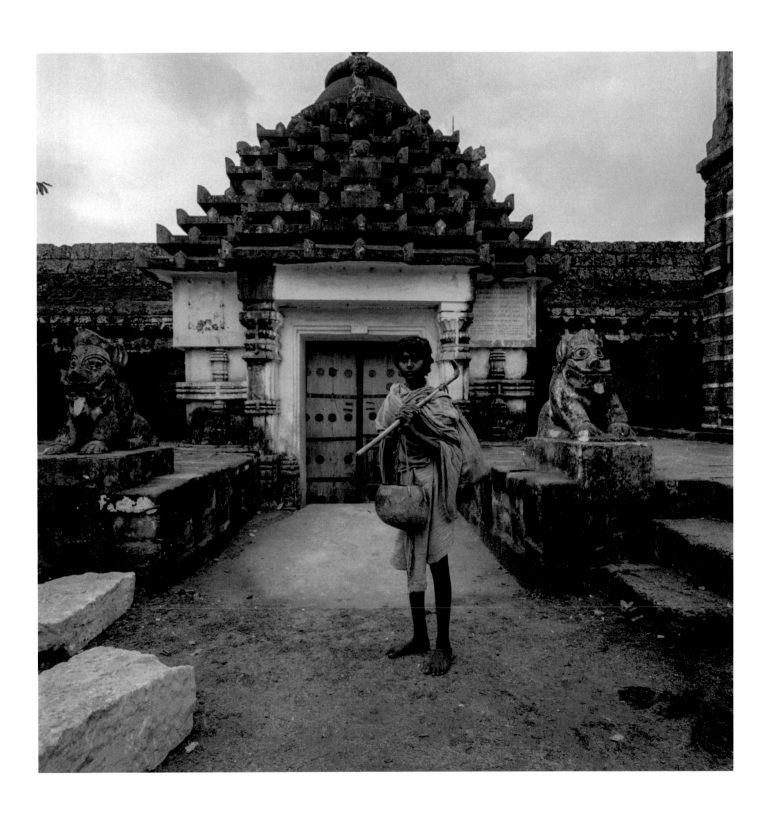

PLATE 26

Lingaraj and Parbati Temple, Orissa, 1976

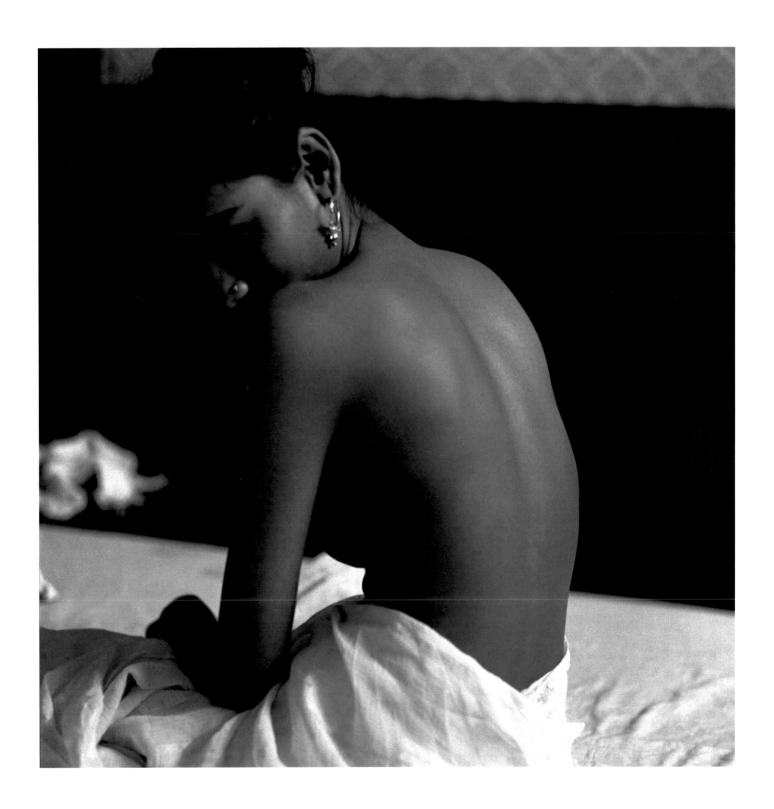

PLATE 27

A young prostitute, Bombay, 1976

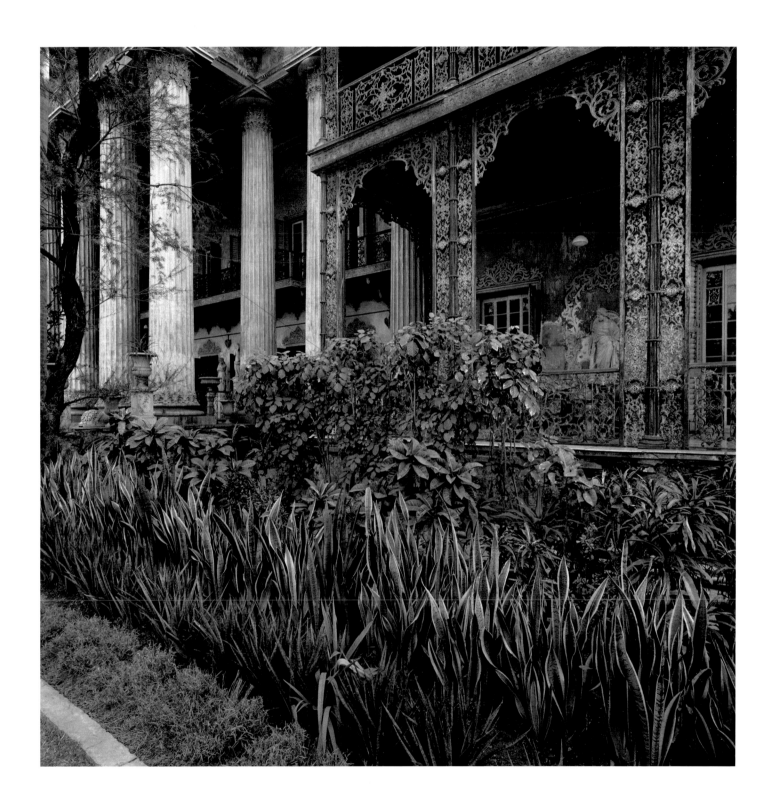

PLATE 28

Exterior, Marble Palace, Calcutta, 1977

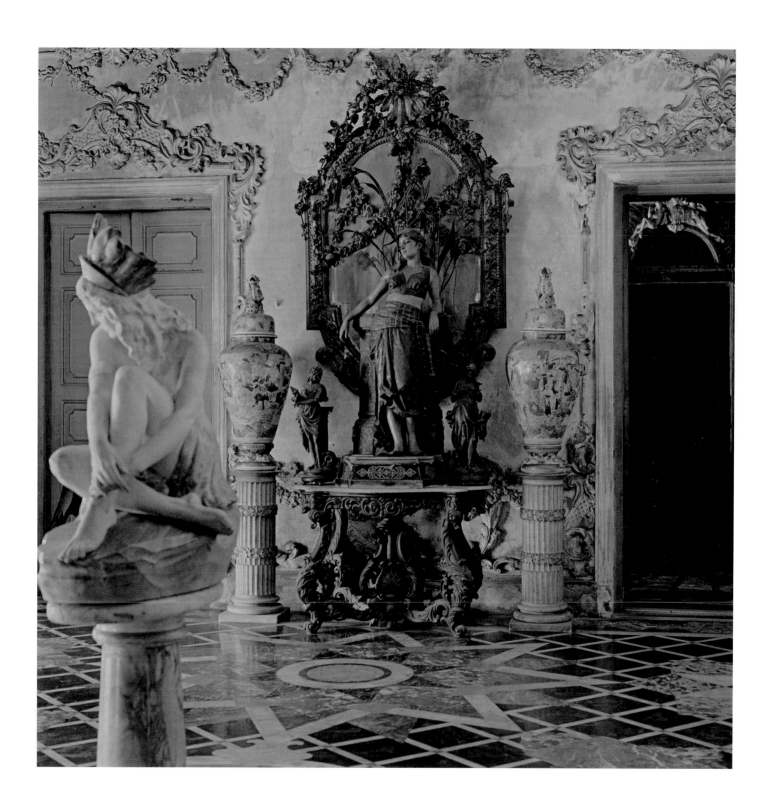

PLATE 29

Interior I, Marble Palace, Calcutta, 1977

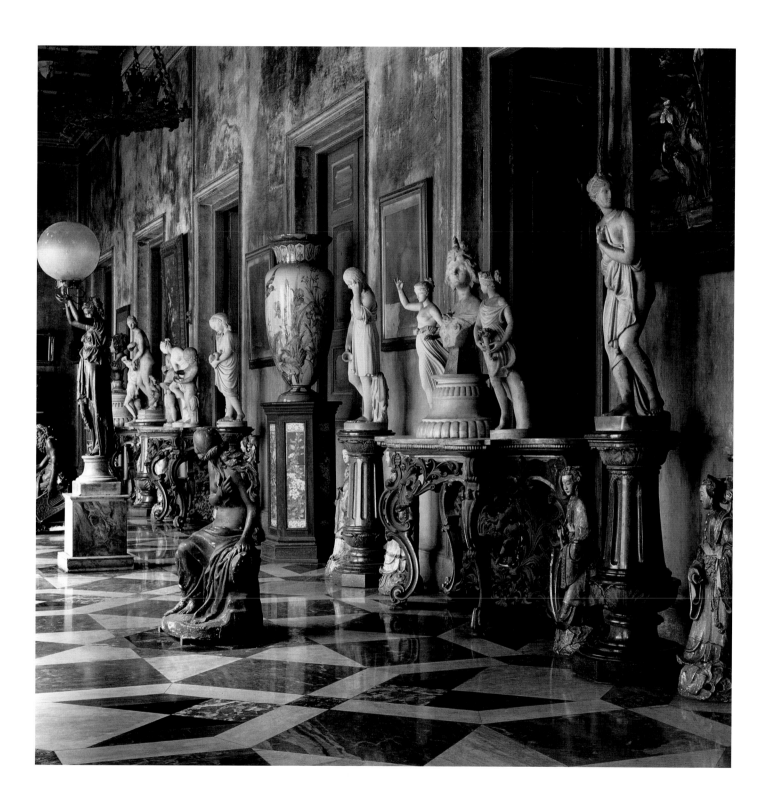

PLATE 30

Interior II, Marble Palace, Calcutta, 1977

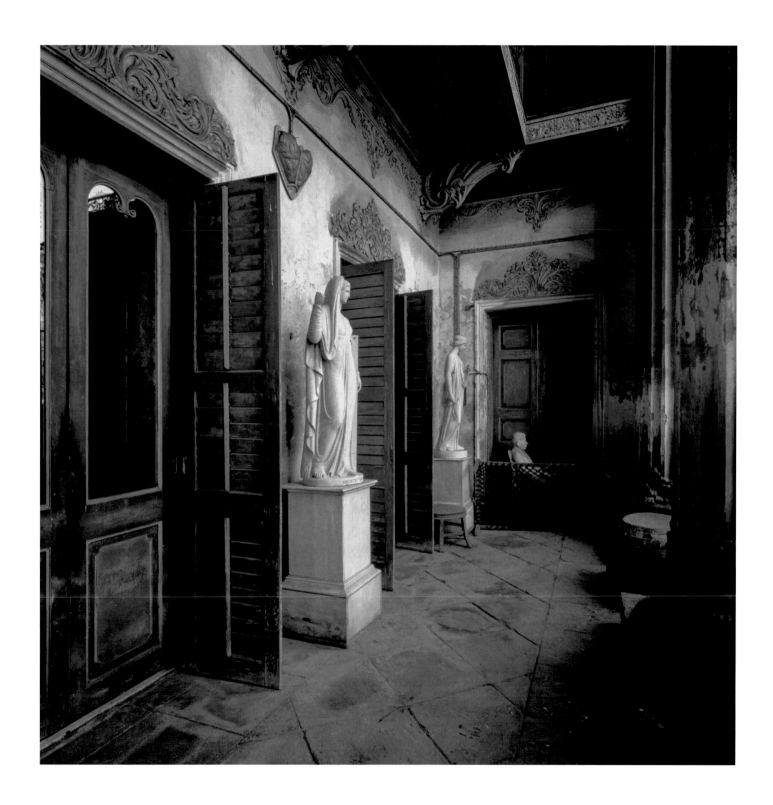

PLATE 31

Interior III, Marble Palace, Calcutta, 1977

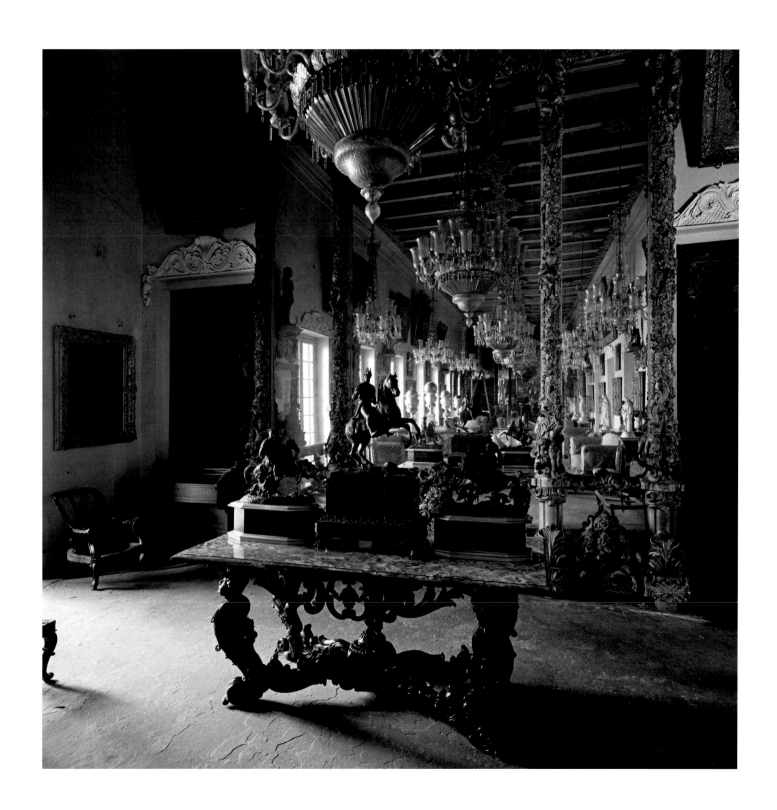

PLATE 32

Interior IV, Marble Palace, Calcutta, 1977

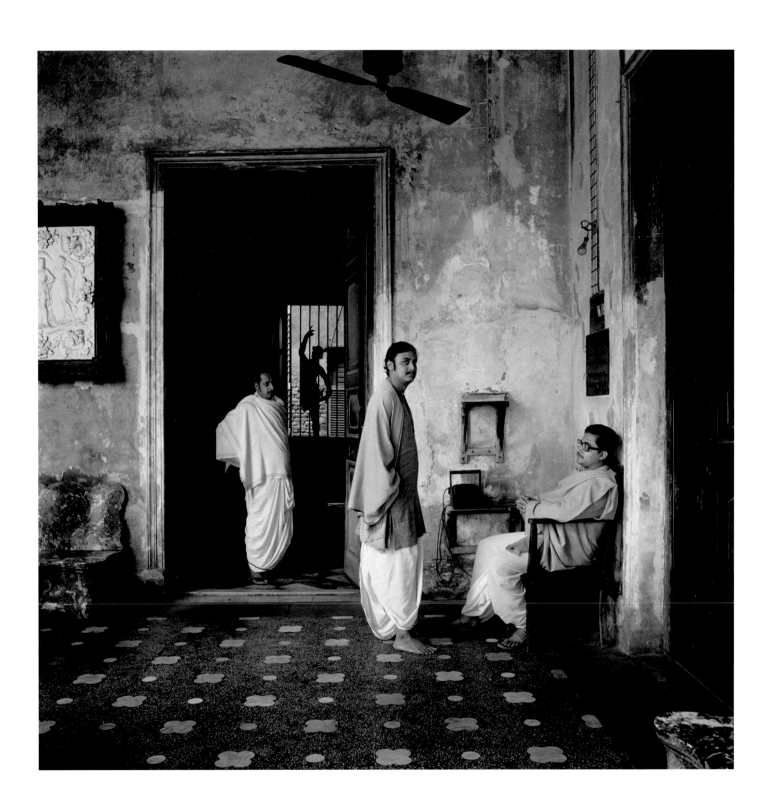

PLATE 33

Owners of the Marble Palace, descendants of Raja Rajendra Mullick,
Calcutta, 1977

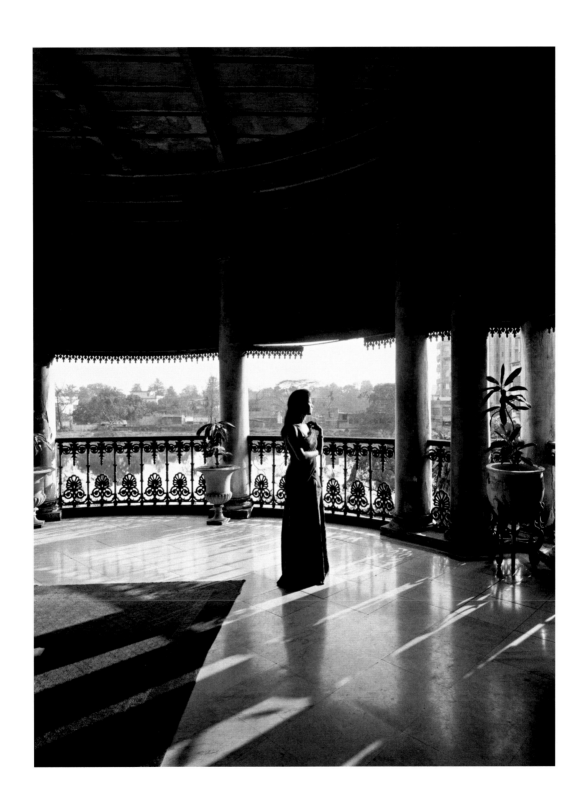

PLATE 34

Nandini Mahtab on the verandah,
Burdwan House, Calcutta, 1977

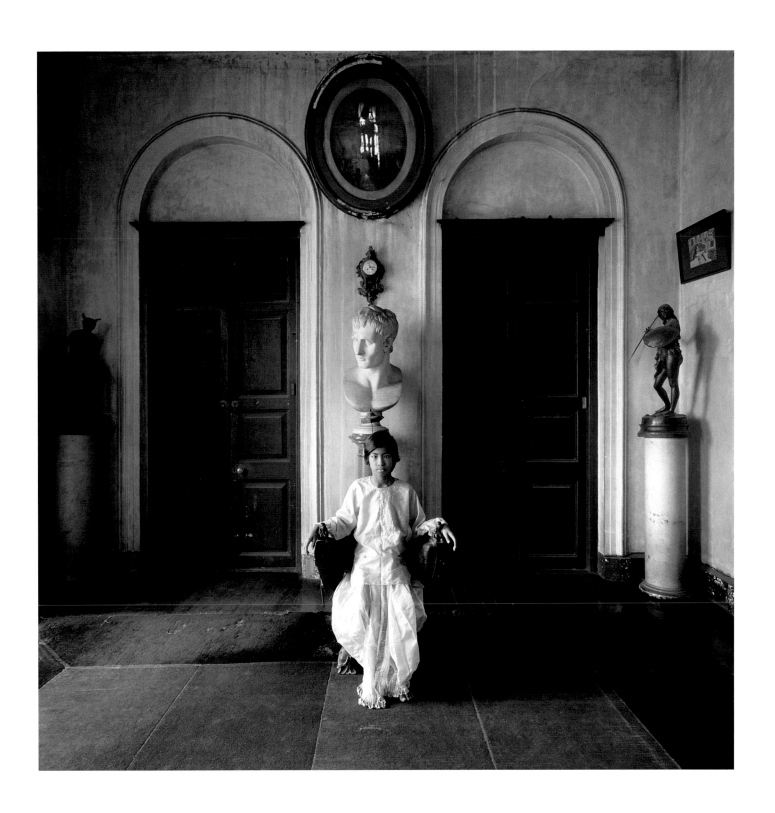

PLATE 35

Ajoy Chand Mahtab, Burdwan House, Calcutta, 1977

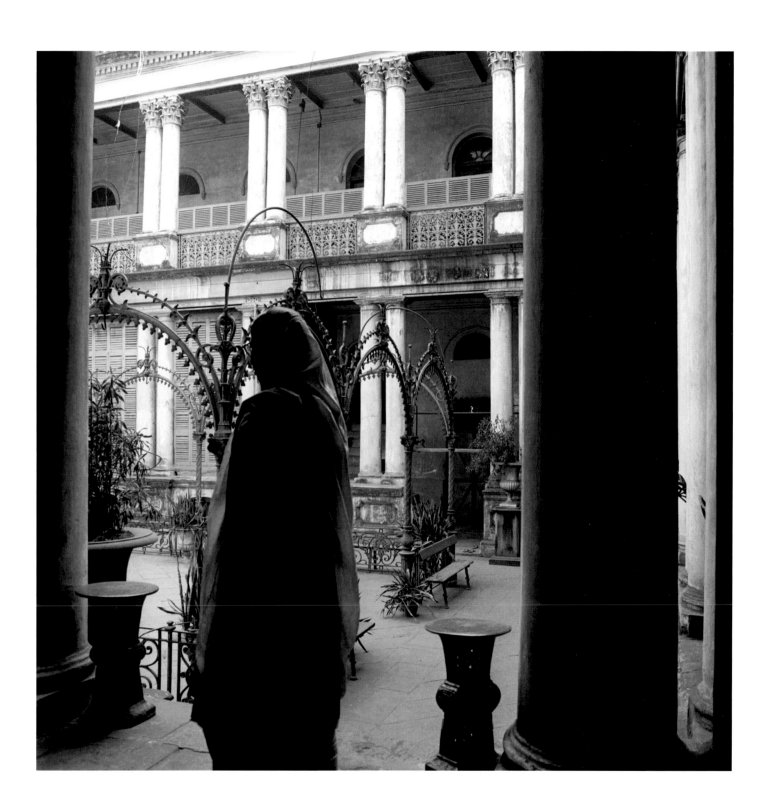

PLATE 36

Lady in a courtyard, Calcutta, 1978

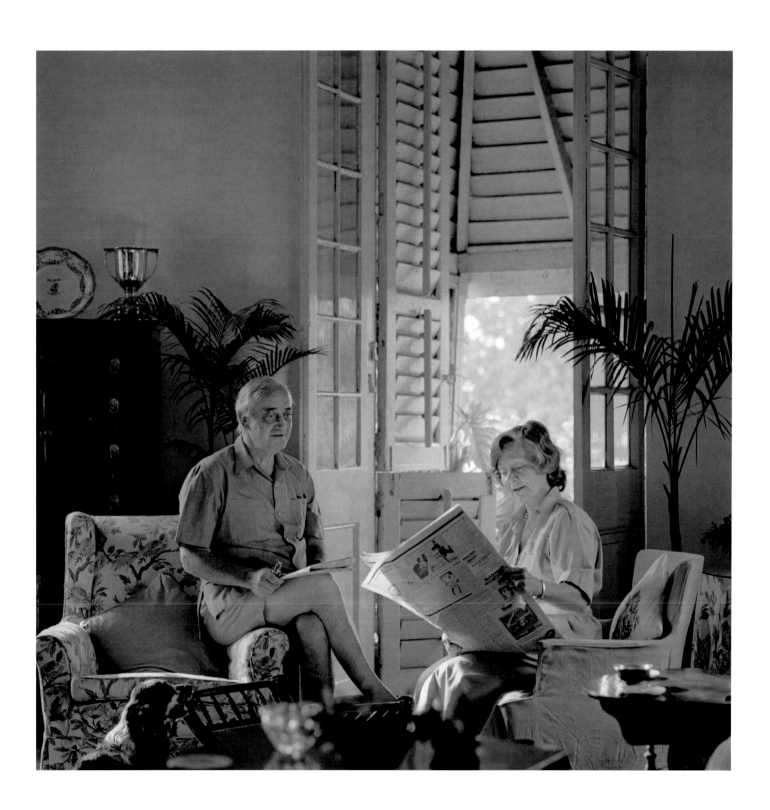

PLATE 37

Bob and Anne Wright, Tollygunge Club, Calcutta, 1988

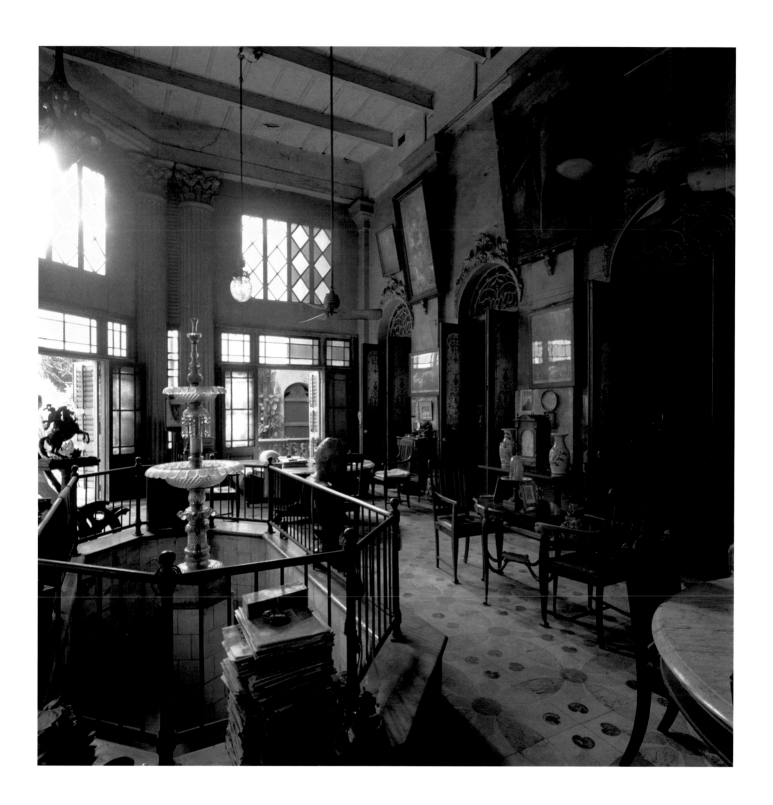

PLATE 38

Mr Mitter's residence, Calcutta, 1980

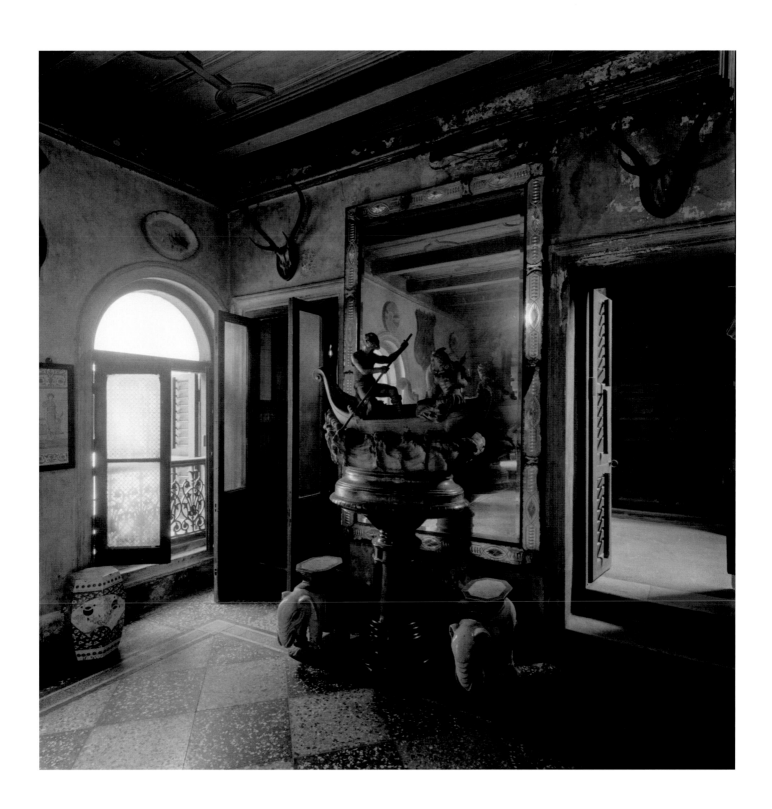

PLATE 39

Interior I, Calcutta, 1980

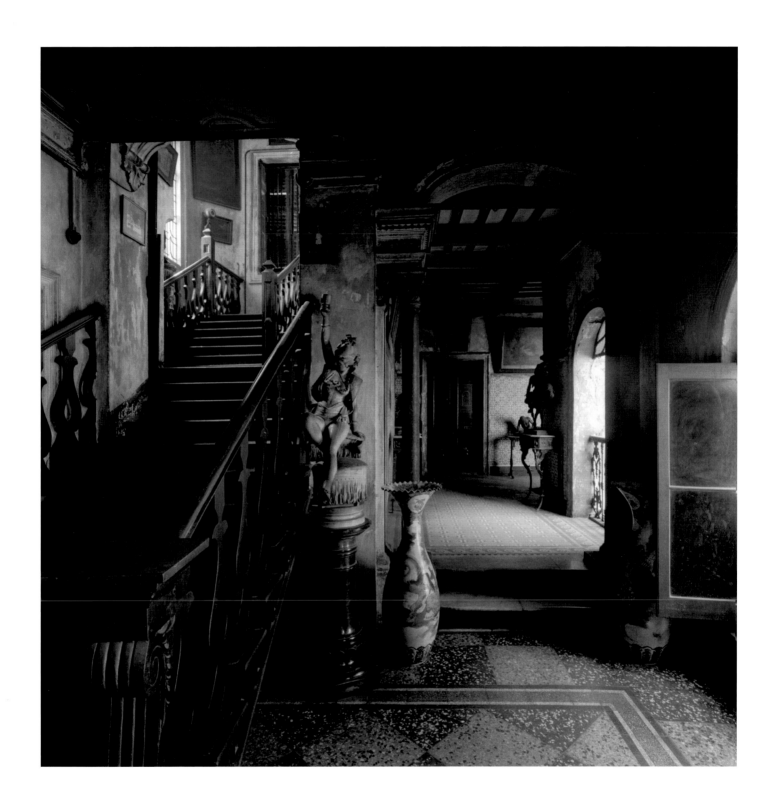

PLATE 40

Interior II, Calcutta, 1980

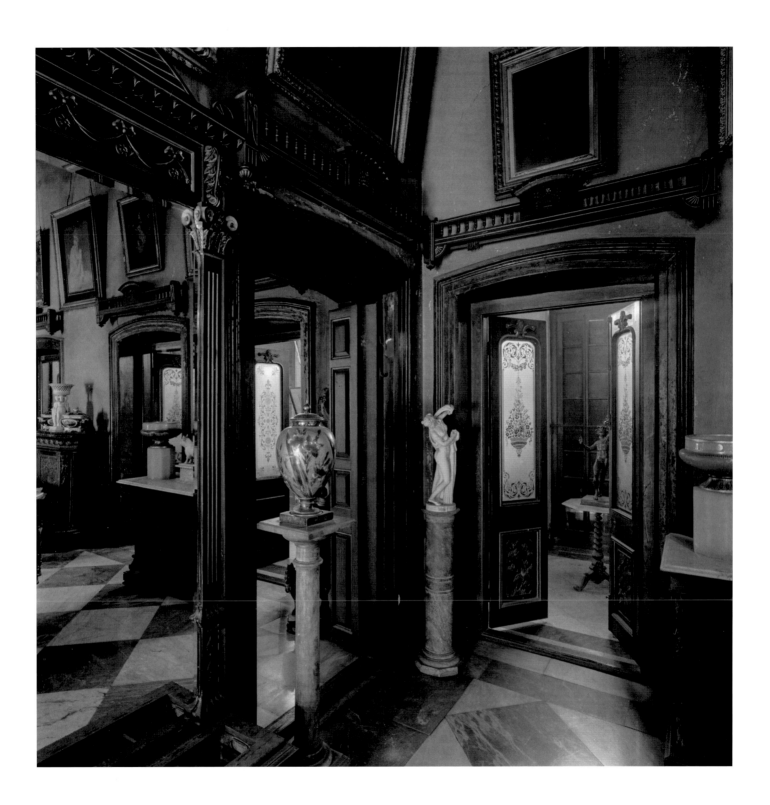

PLATE 41

Interior III, Calcutta, 1980

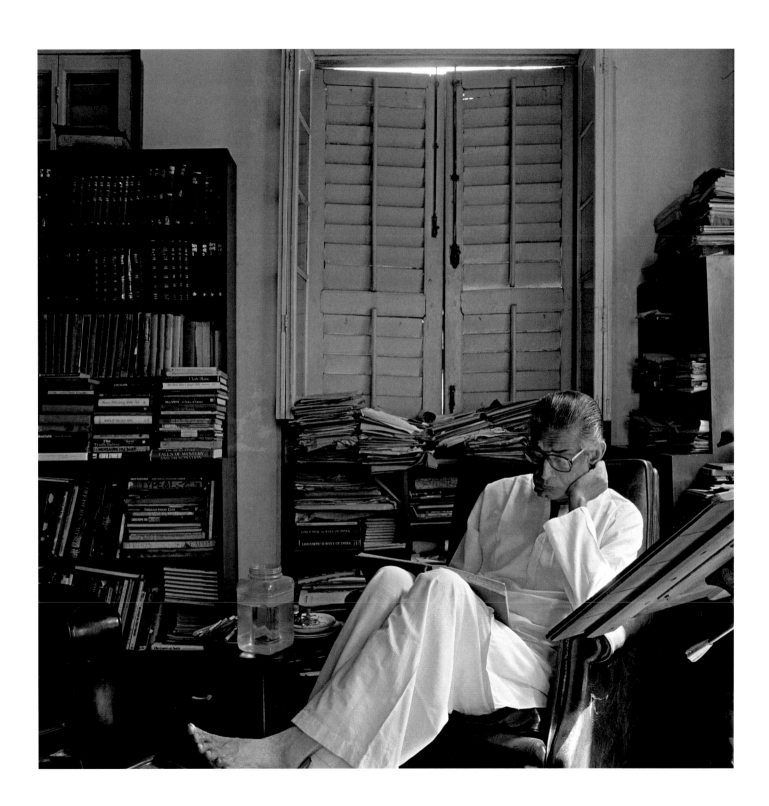

PLATE 42

Satyajit Ray at his residence, Calcutta, 1980

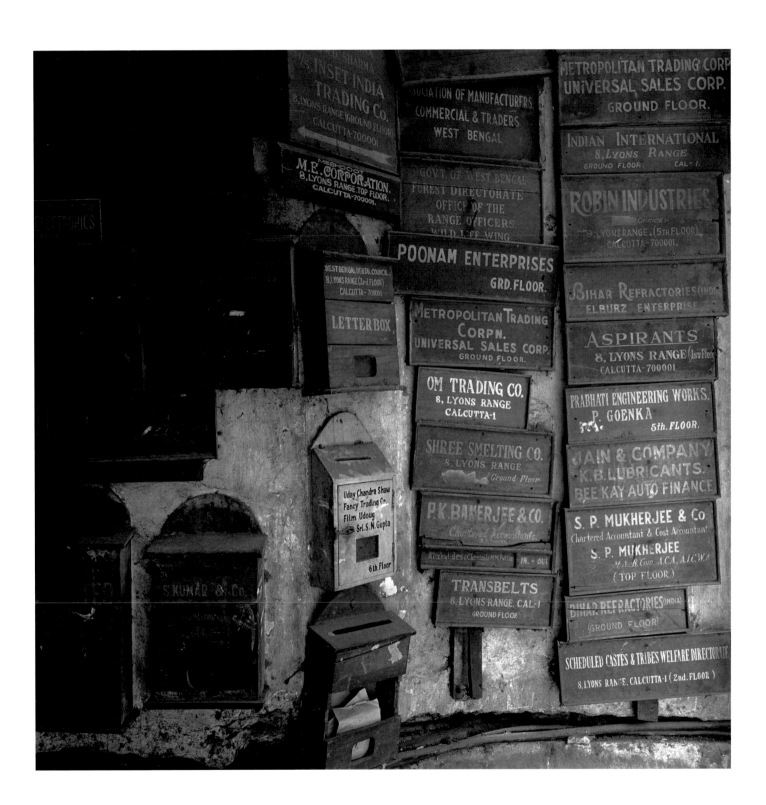

PLATE 43

Letterboxes, Calcutta, 1982

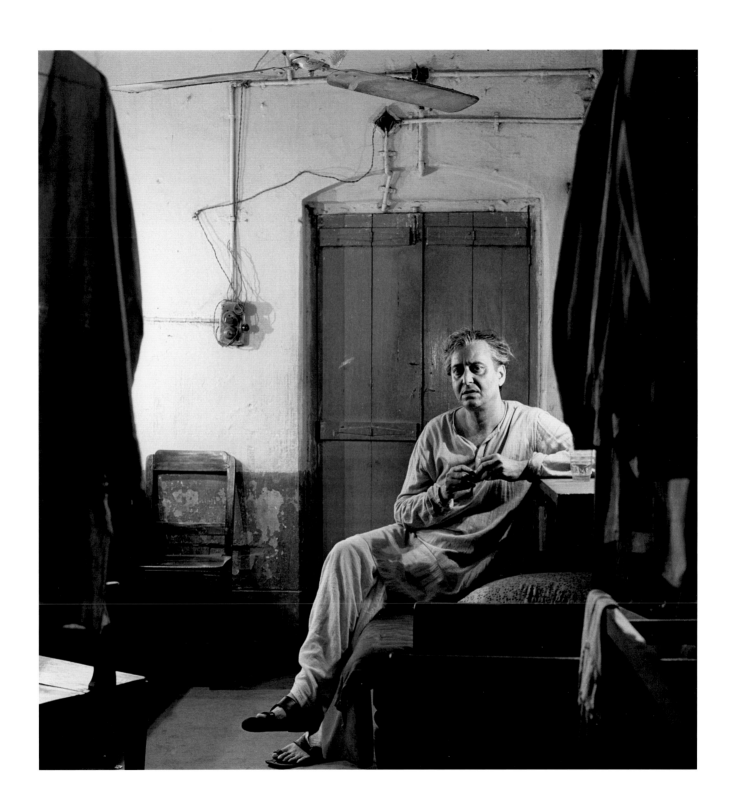

PLATE 44

Soumitra Chatterjee in his dressing room in the theatre,
Calcutta, 1982

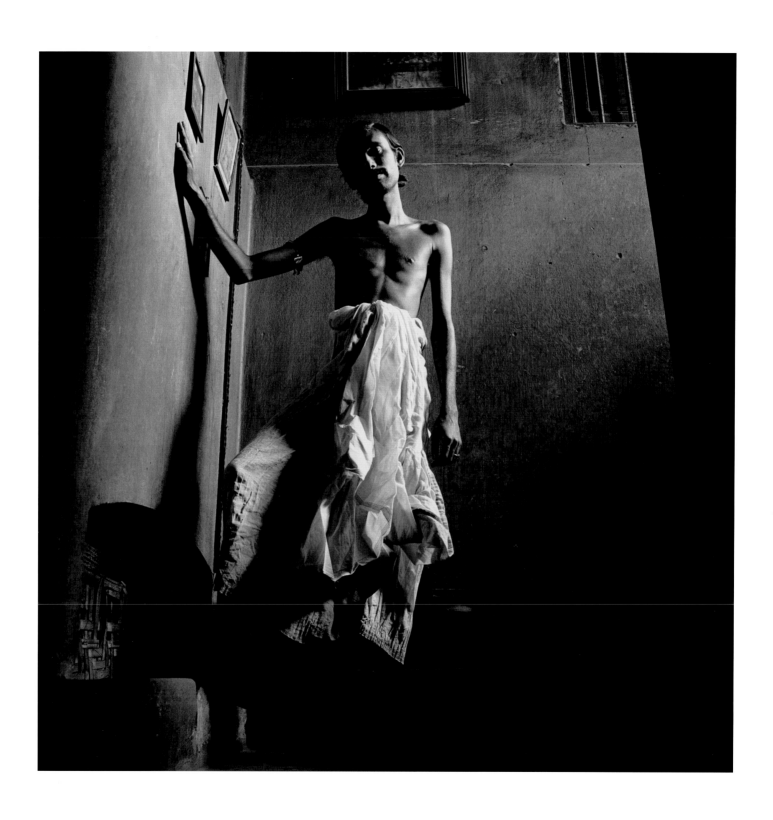

PLATE 45

Man on stairs, Calcutta, 1982

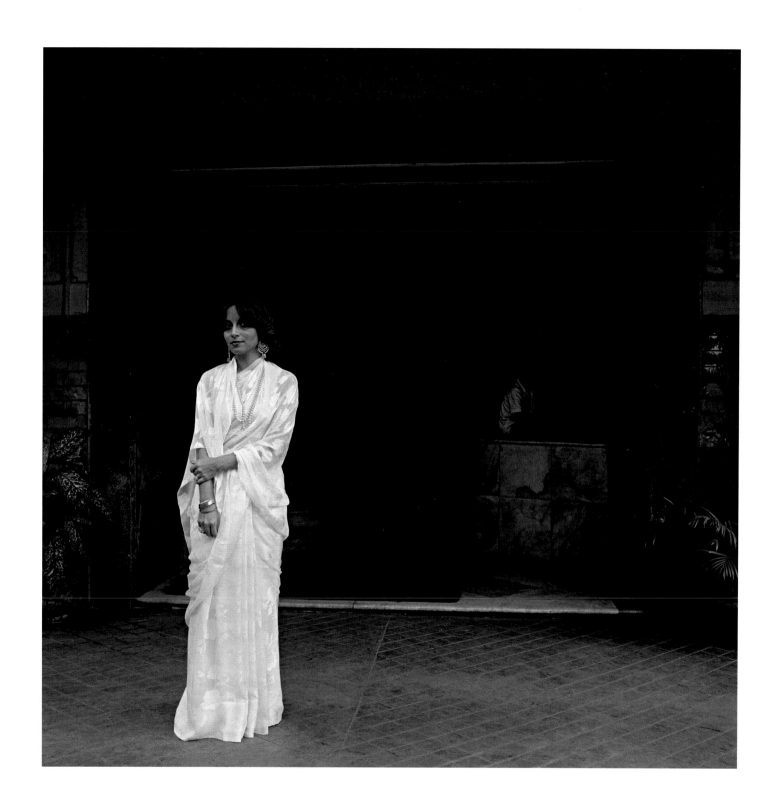

PLATE 46

Sunita Kumar, Calcutta, 1978

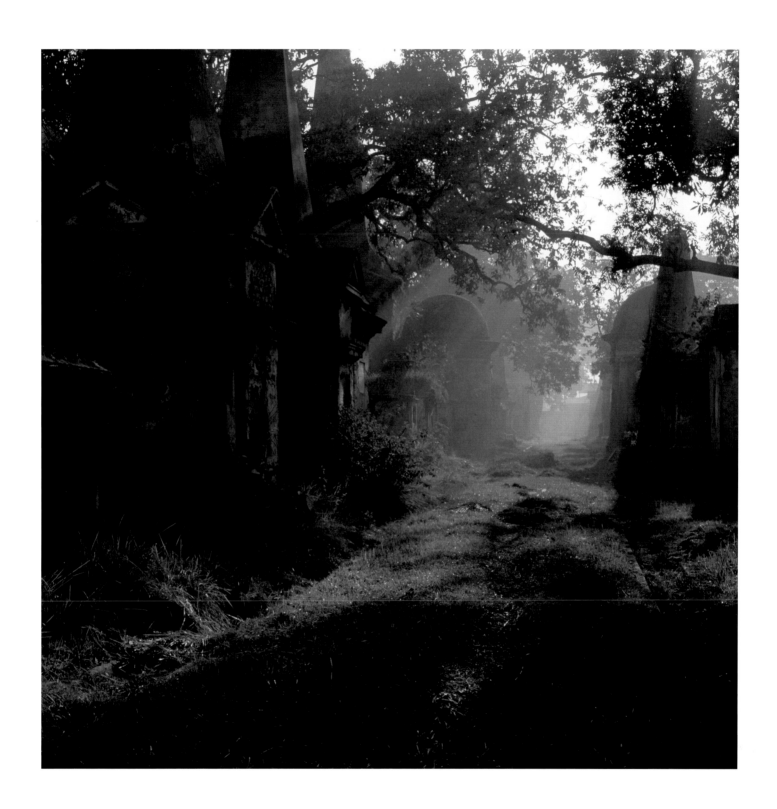

PLATE 47

South Park Cemetery, Calcutta, 1977

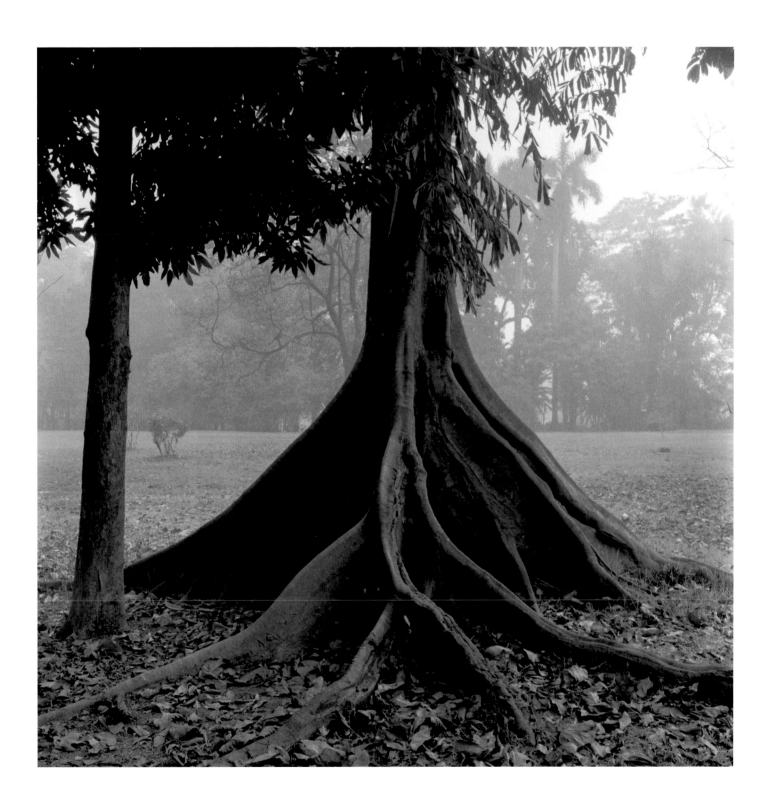

PLATE 48

Botanical Gardens, Calcutta, 1977

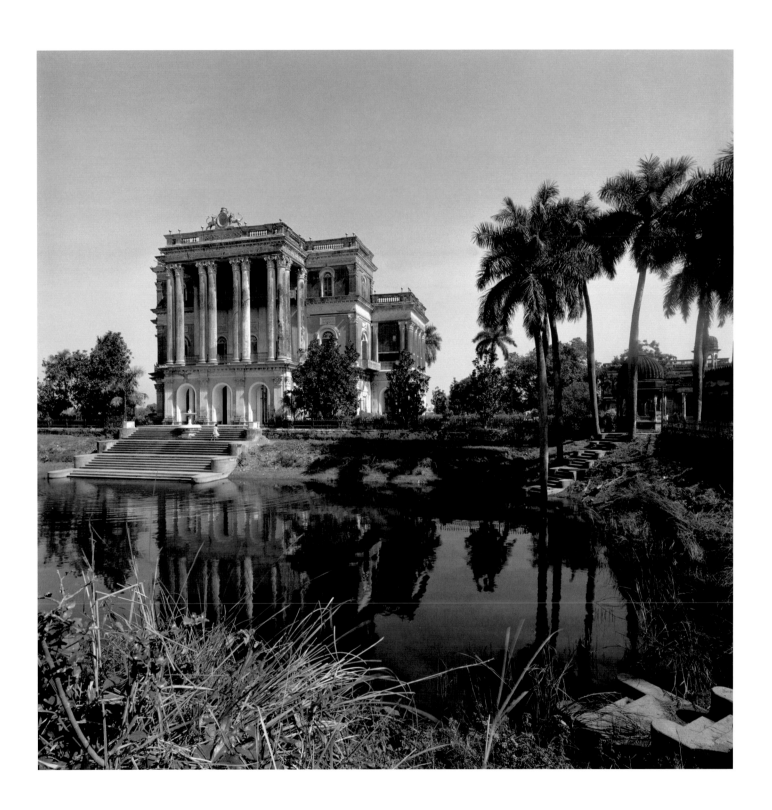

PLATE 49

Kathgola Palace, Murshidabad, 1980

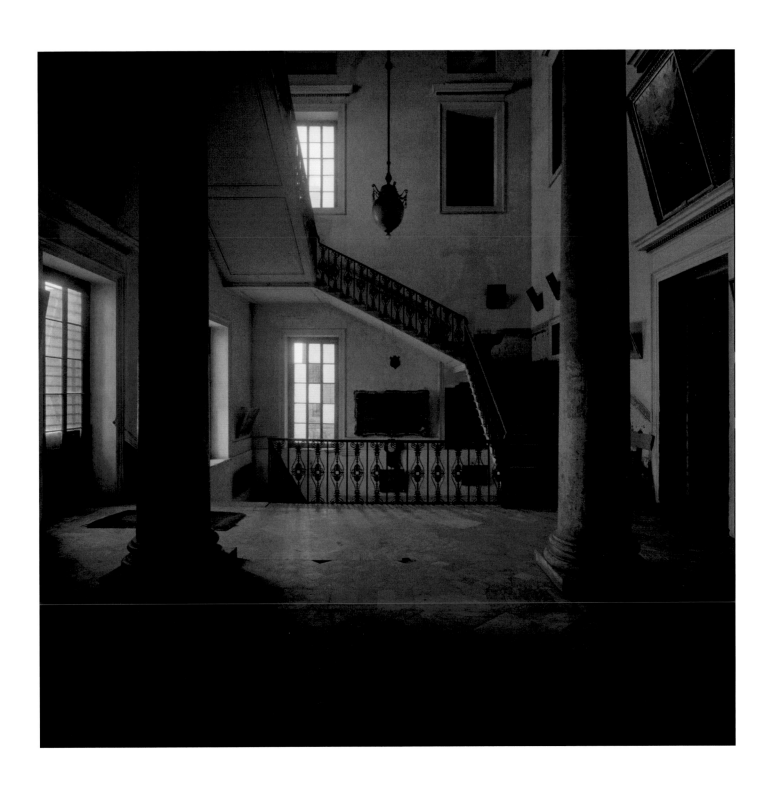

PLATE 50

Interior I, The Nawab's Palace, Murshidabad, 1980

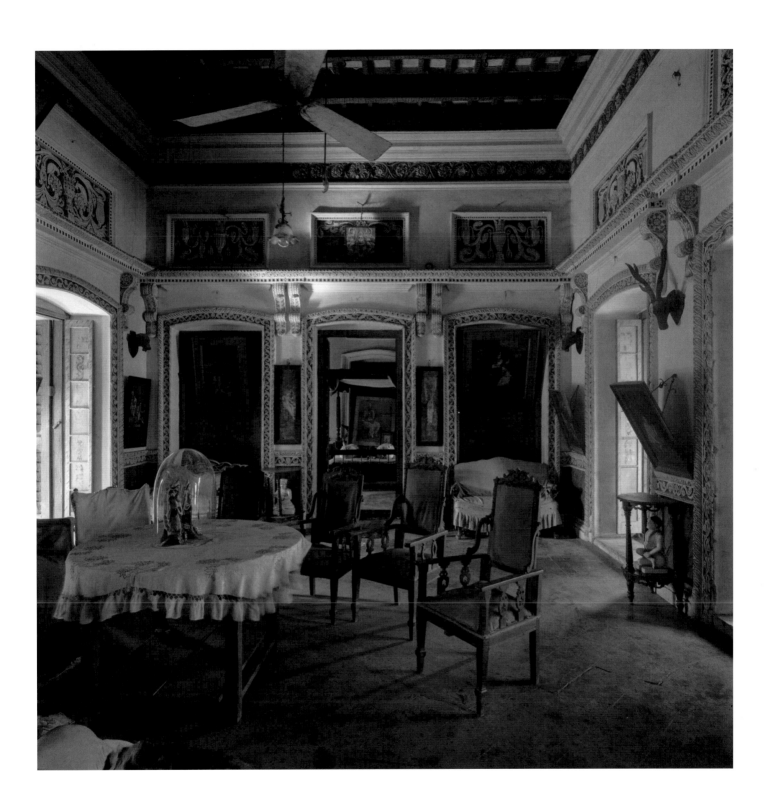

PLATE 51

Interior II, The Nawab's Palace, Murshidabad, 1980

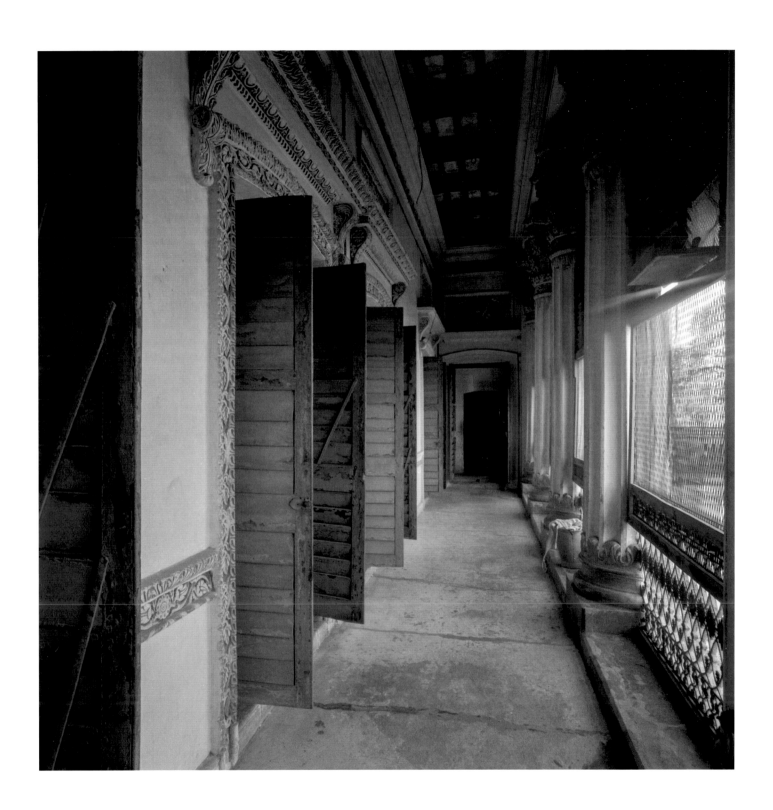

PLATE 52

Corridor, Palace, Murshidabad, 1980

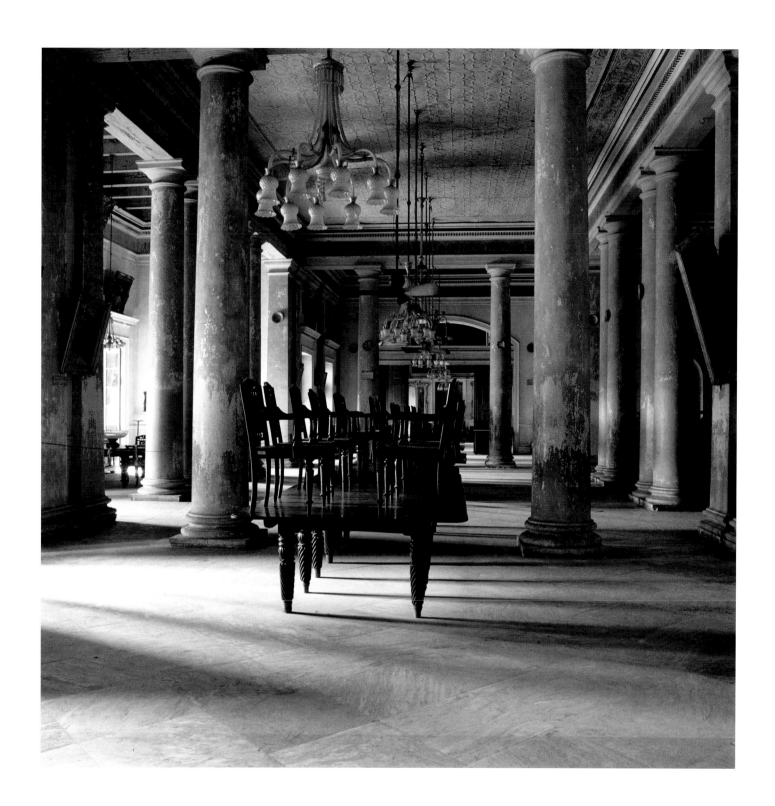

PLATE 53

Dining room, The Nawab's Palace, Murshidabad Palace, 1980

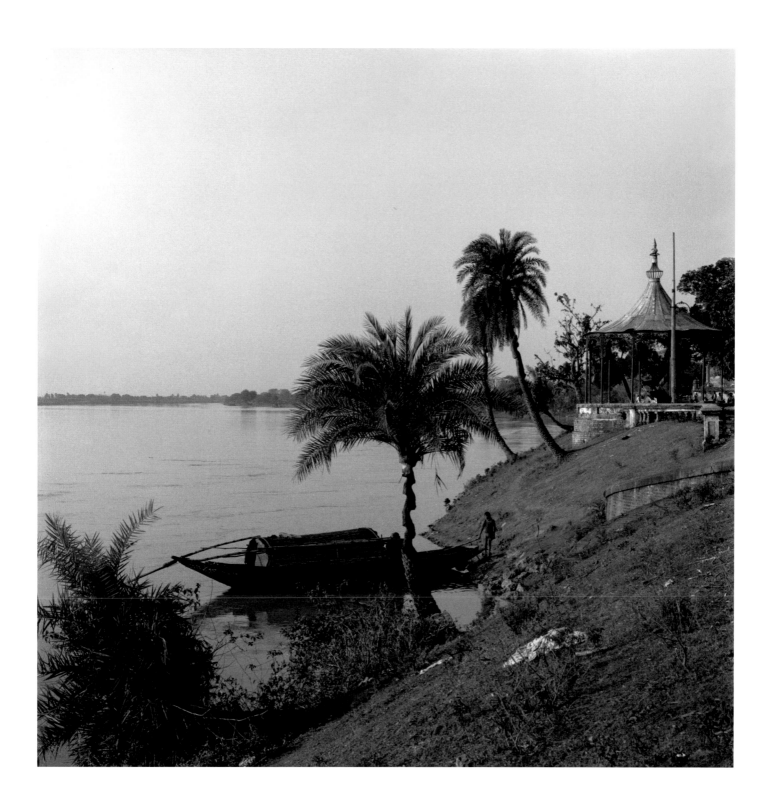

PLATE 54

By the Jalangi River, Murshidabad, 1980

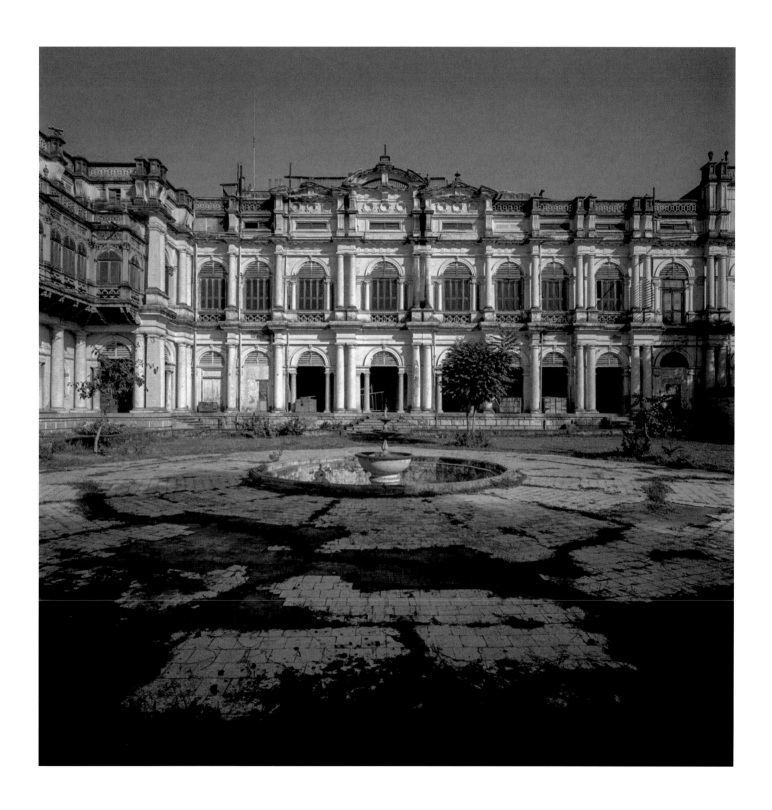

PLATE 55

Courtyard, Jai Vilas Mahal, Gwalior, 1984

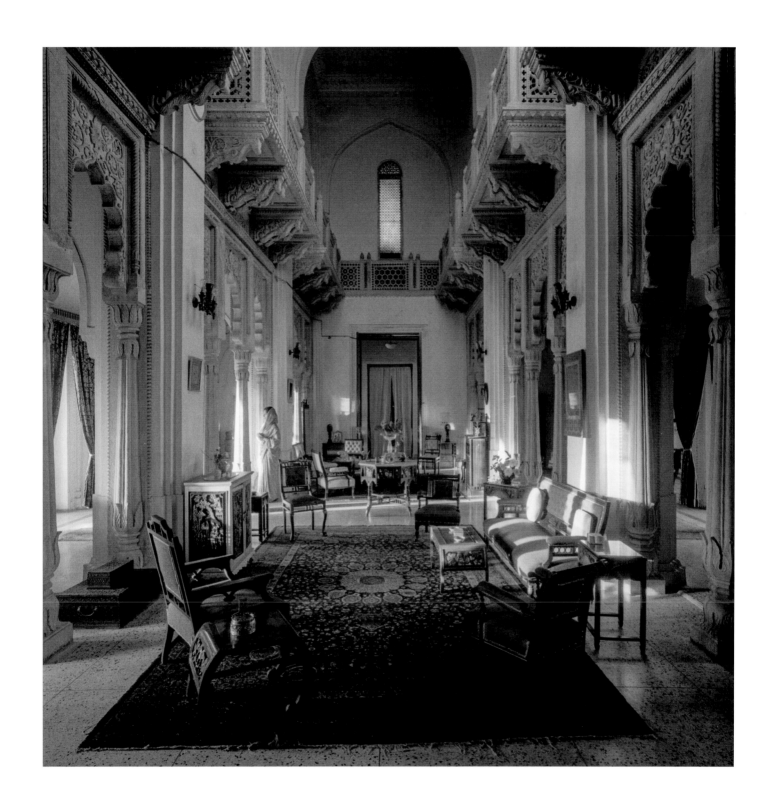

PLATE 56

Lady by the window, Gwalior, 1984

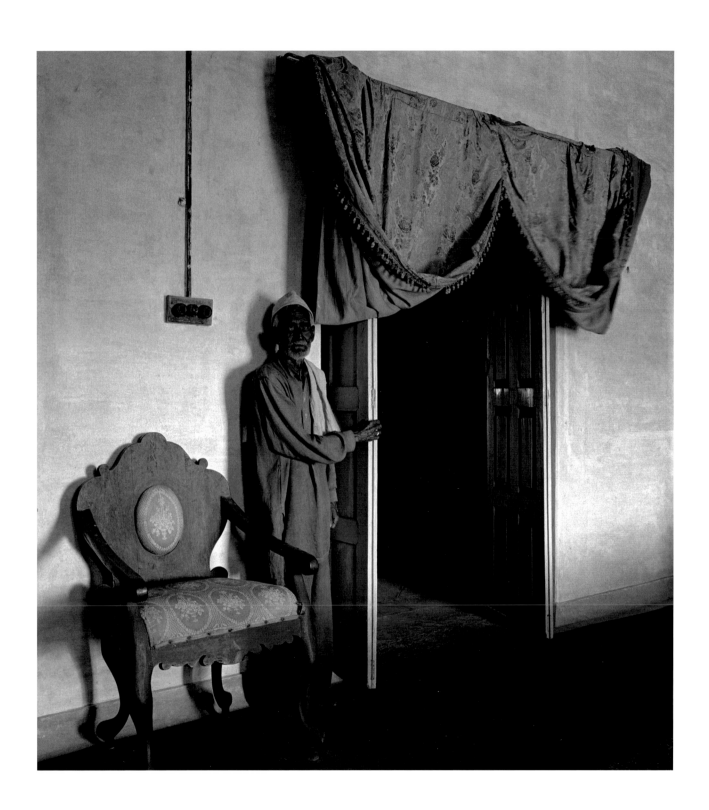

PLATE 57

Servant, Palace, Datia, 1984

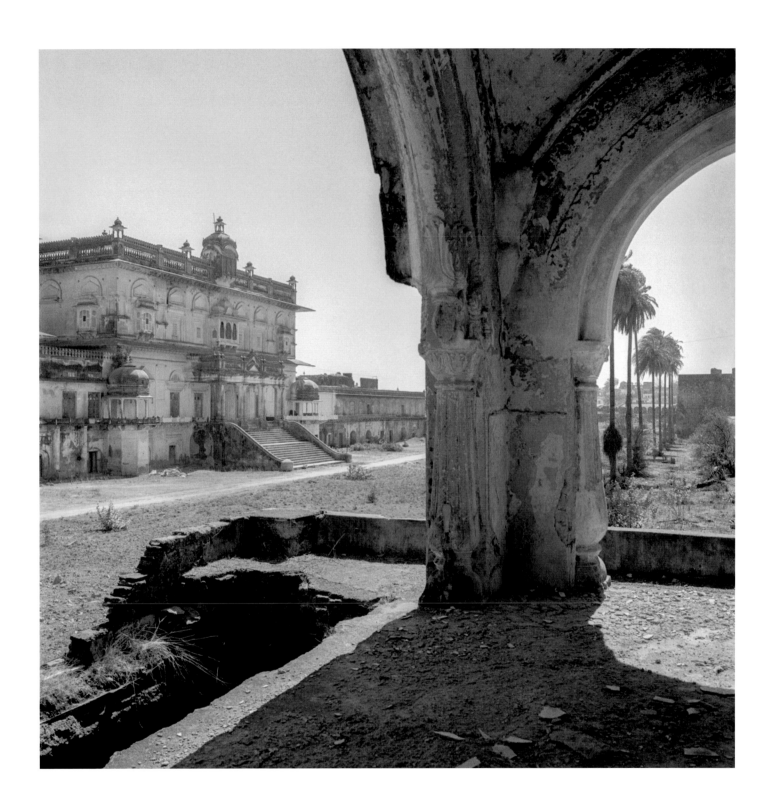

PLATE 58

View through an arch, Datia, 1984

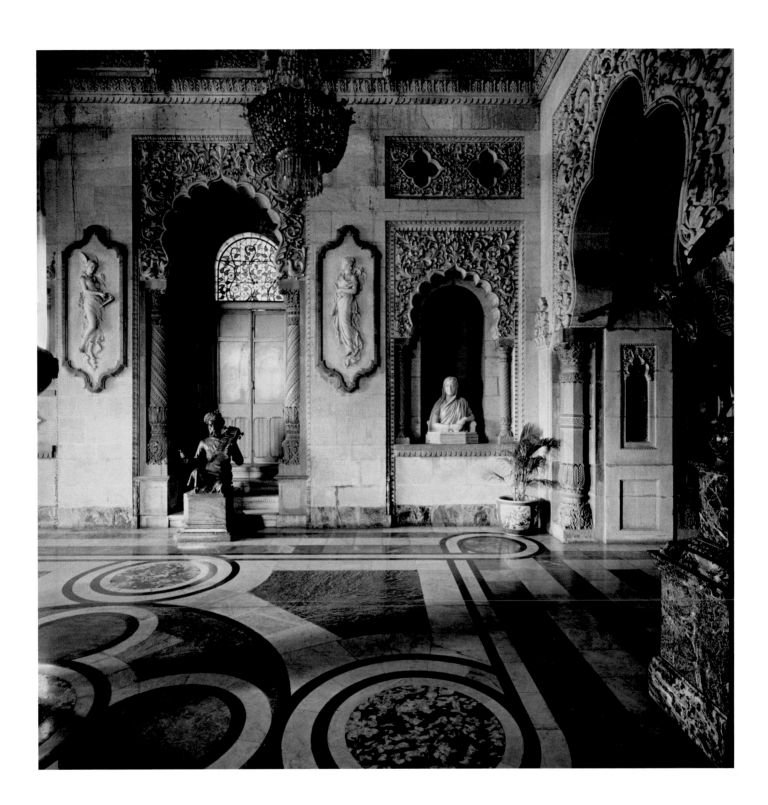

PLATE 59

Entrance foyer, Lukshmi Vilas Palace, Baroda, 2012

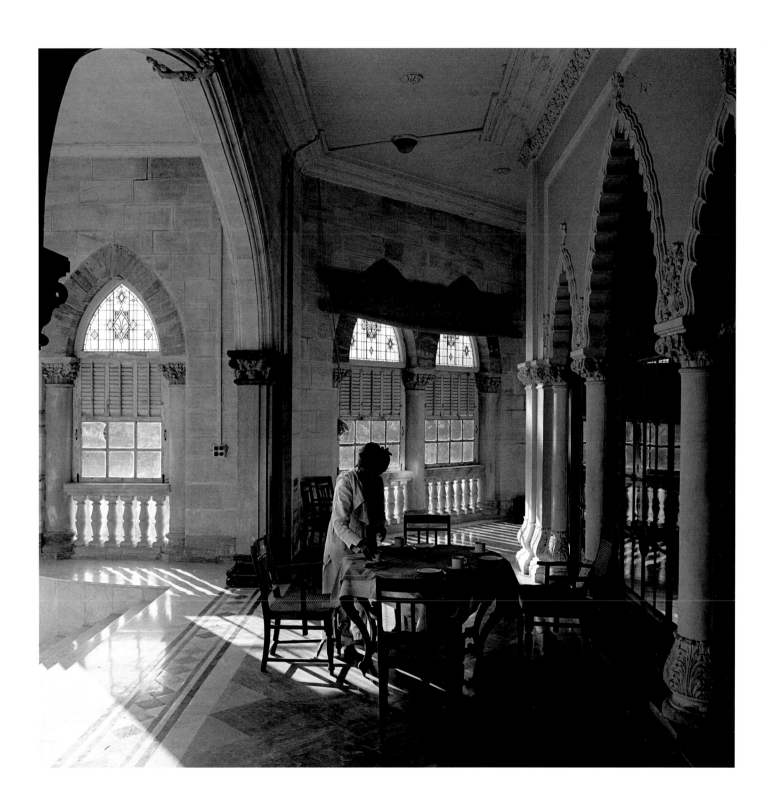

PLATE 60

Servant serving tea, Royal Palace, Wankaner, 1982

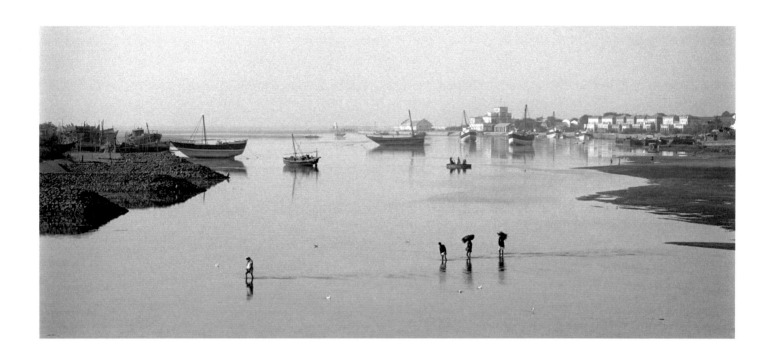

PLATE 61

Riverside view, Gujarat, 1982

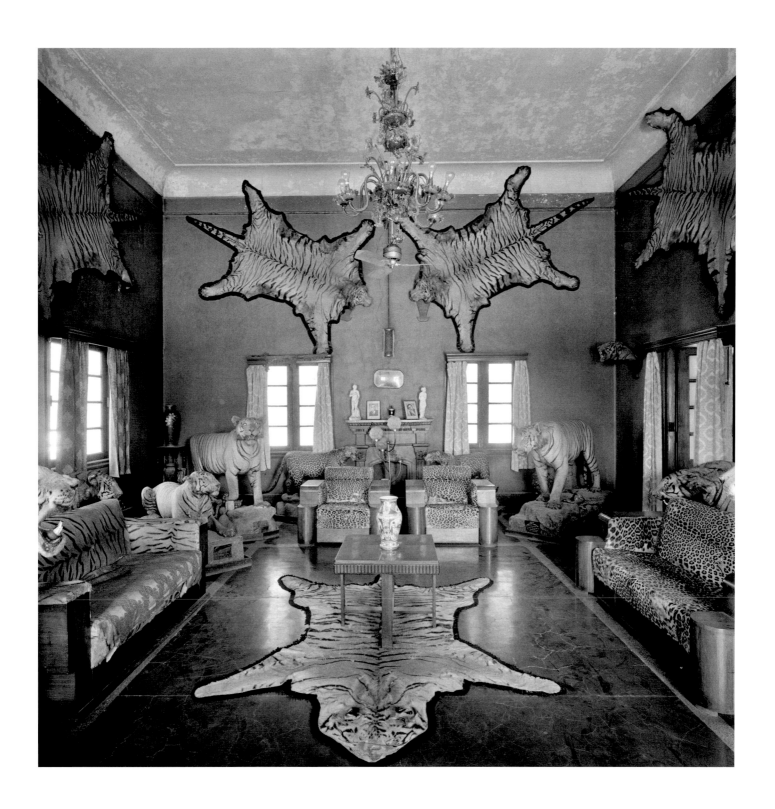

PLATE 62

Drawing room, Rajasthan, 1980

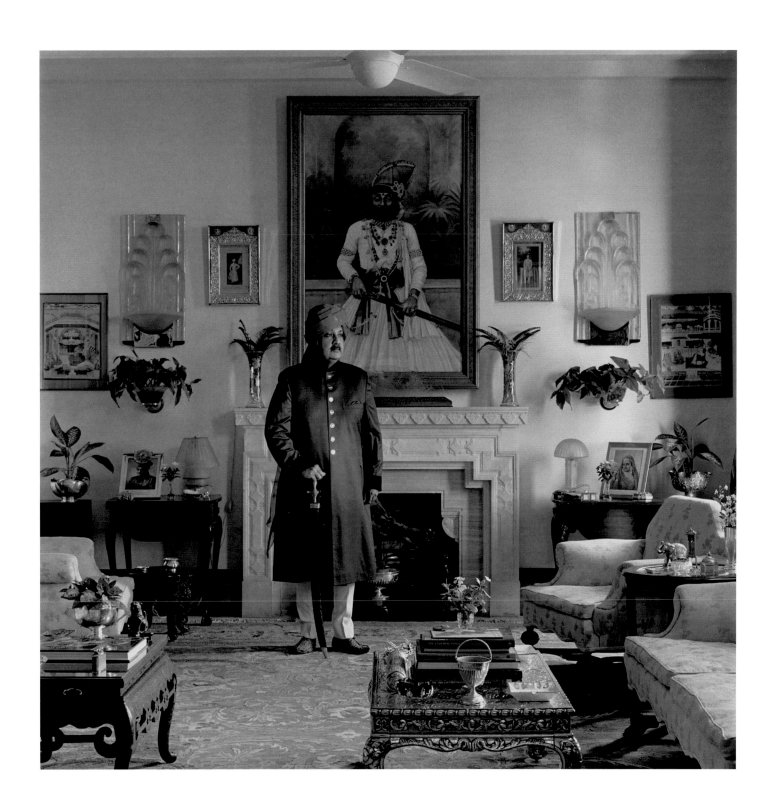

PLATE 63

H. H. Maharaja Gaj Singh of Jodhpur in front of a portrait of H. H. Takht Singh,
Jodhpur, 2007

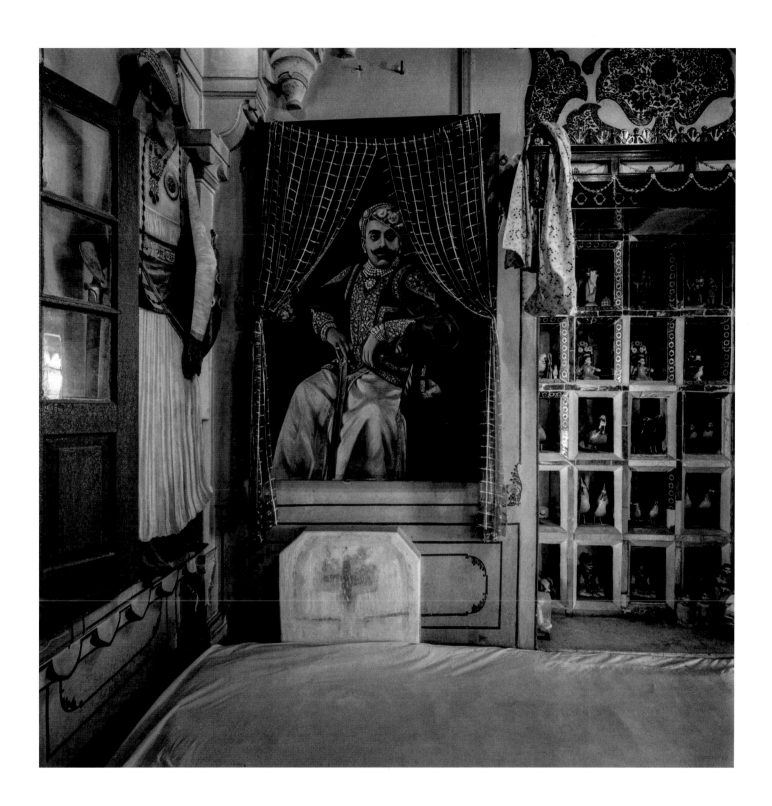

PLATE 64

Life-size painting of the late H. H. Bhupal Singh Bahadur (Maharana of Mewar and Udaipur),
Brij Vilas, City Palace, Udaipur, 1978

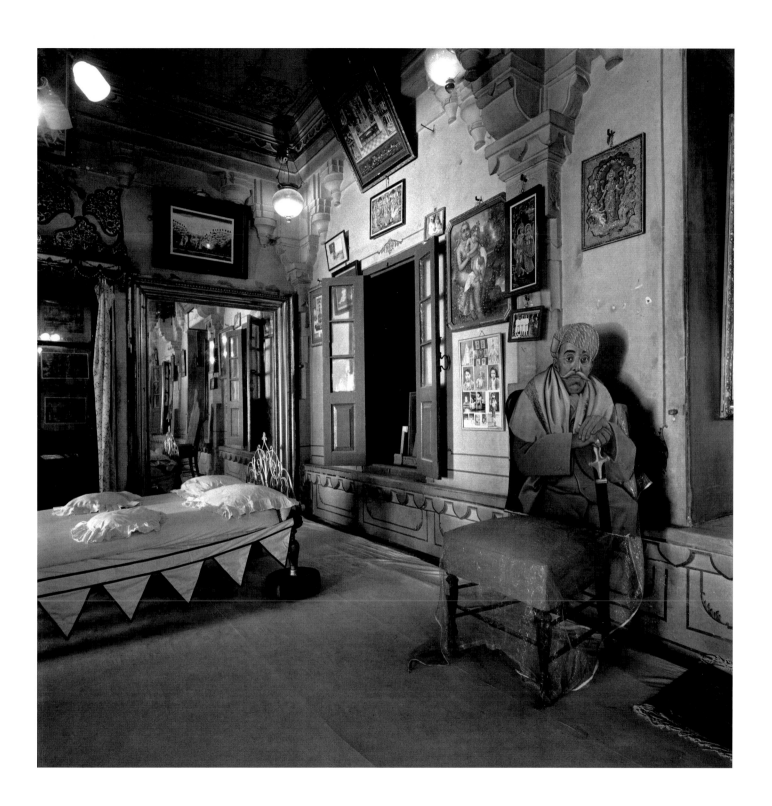

PLATE 65

Bhupal Vilas, North wing of the Zenana Mahal,
City Palace, Udaipur, 1978

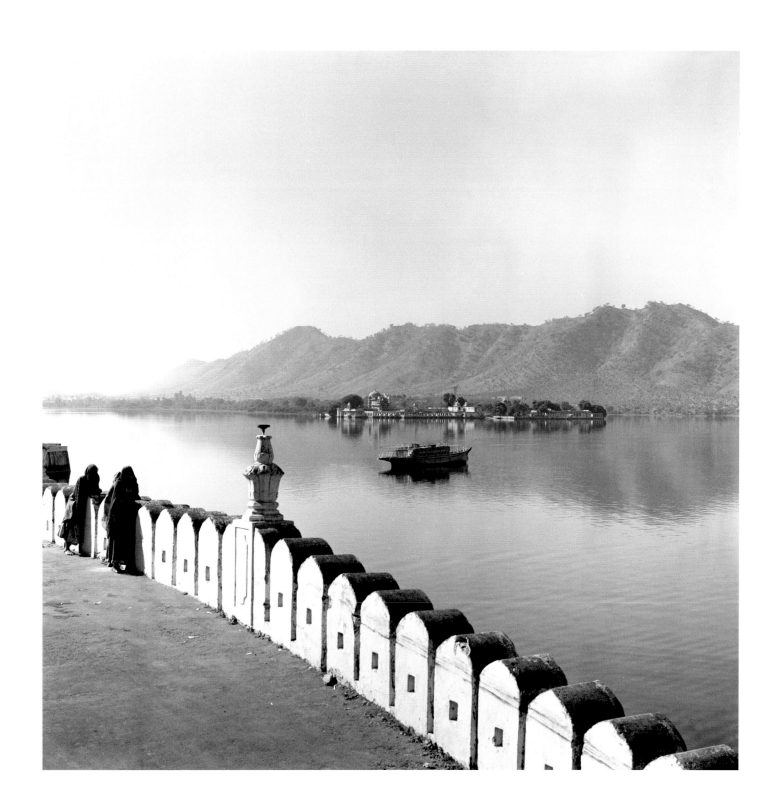

PLATE 66

View of Jag Mandir, Lake Pichola, Udaipur, 1978

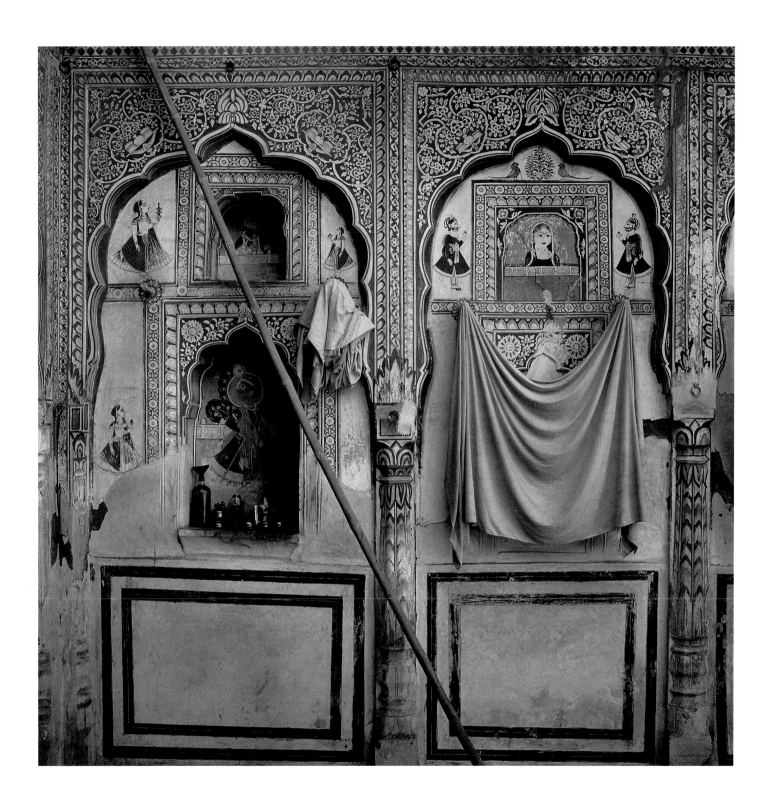

PLATE 67

Shekawati mural, Haveli wall, Rajasthan, 1982

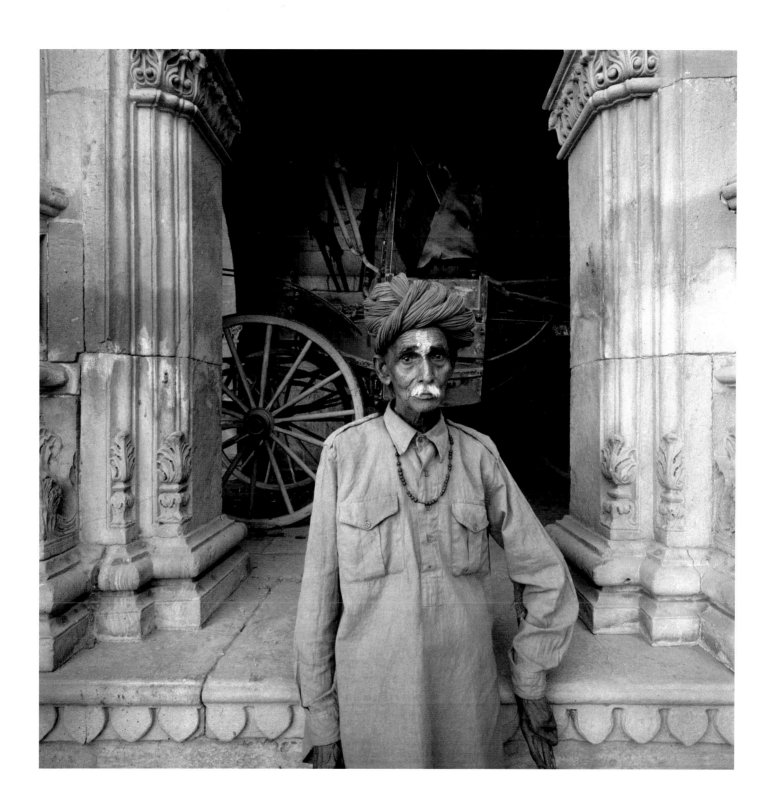

PLATE 68

Guard, Royal Palace, Jaisalmer, 1977

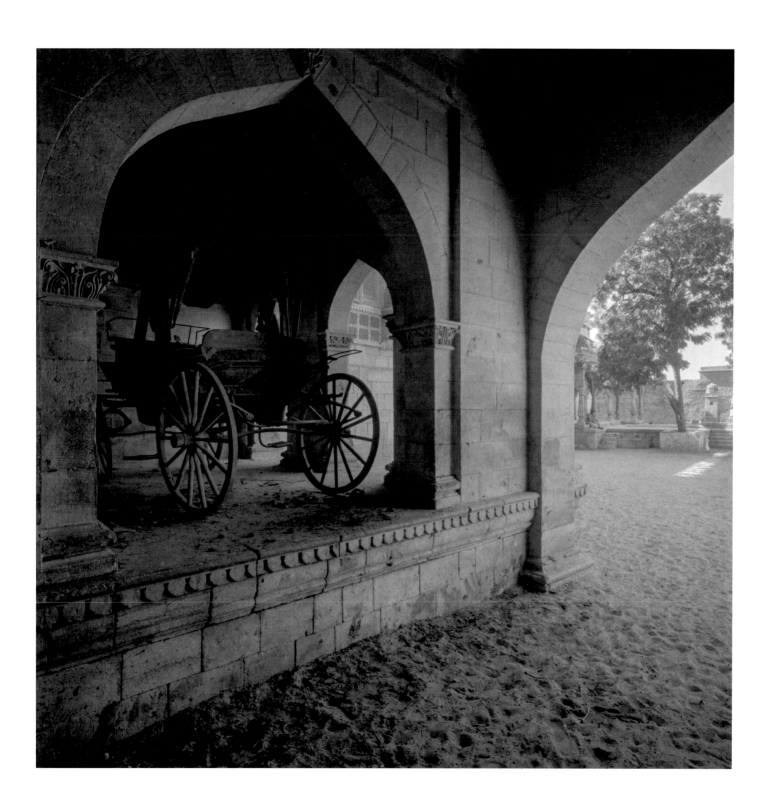

PLATE 69

Carriage, Royal Palace, Jaisalmer, 1977

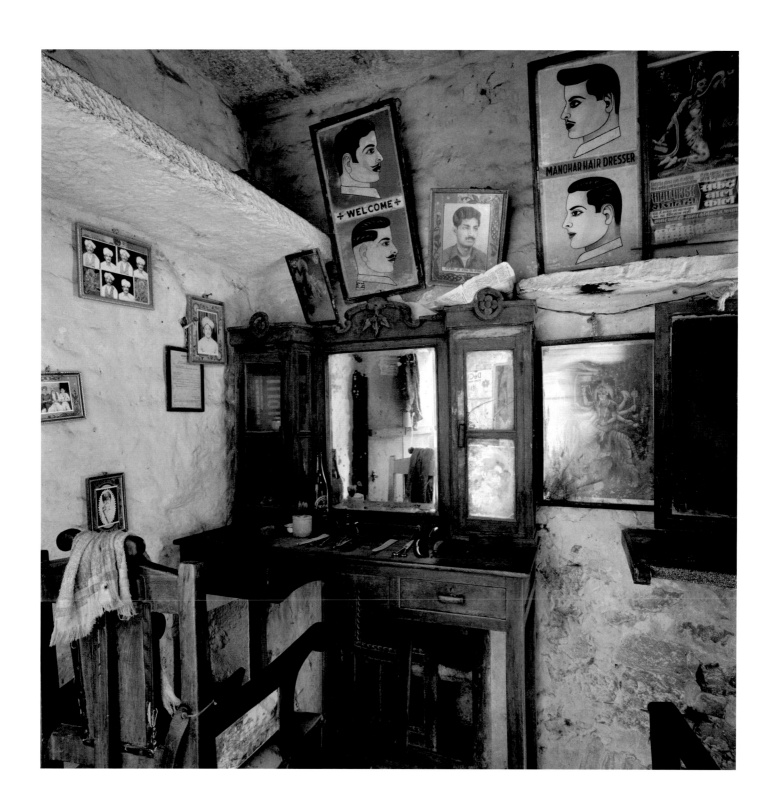

PLATE 70

Barber's shop, Jaisalmer, 1978

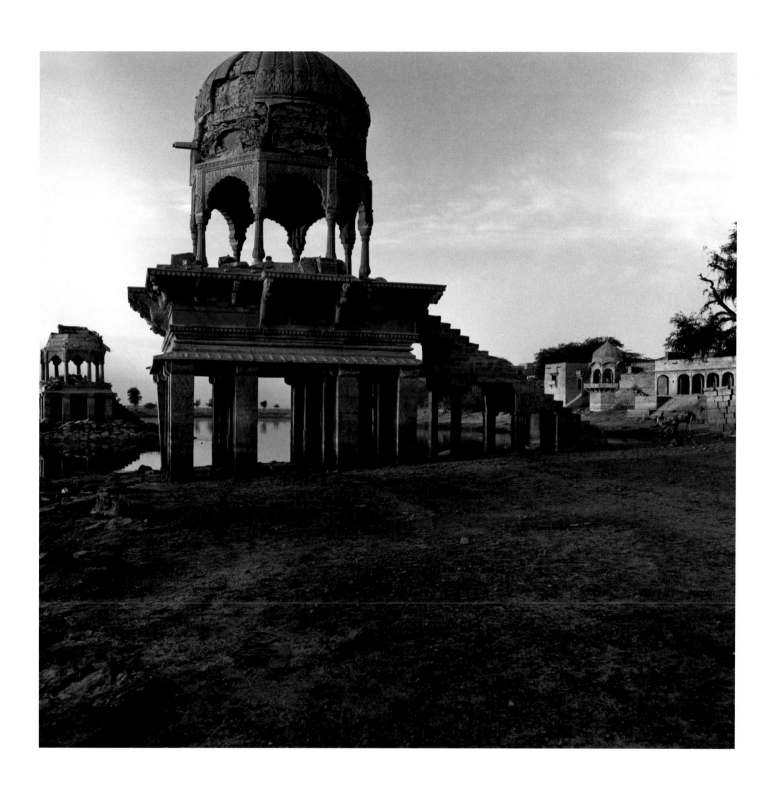

PLATE 71

Gadsisar Lake I, Jaisalmer, 1977

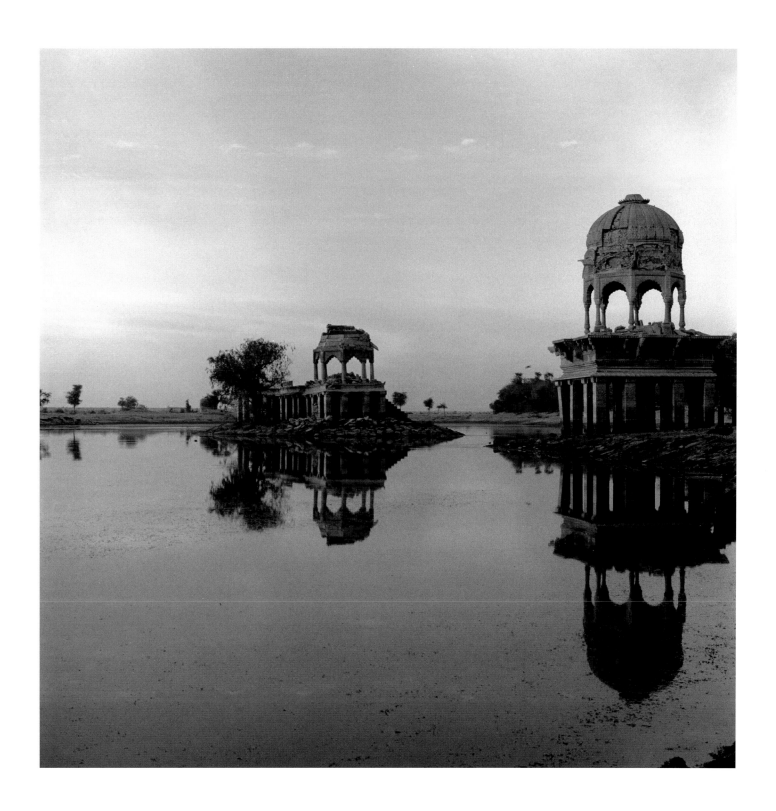

PLATE 72

Gadsisar Lake II, Jaisalmer, 1977

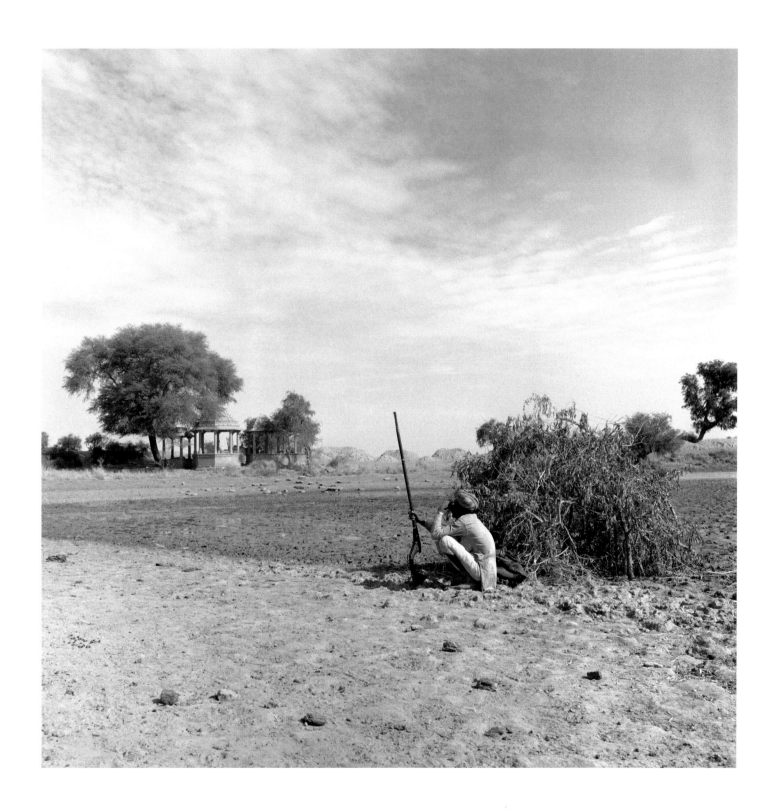

PLATE 73

Hunter, Bikaner countryside, 1982

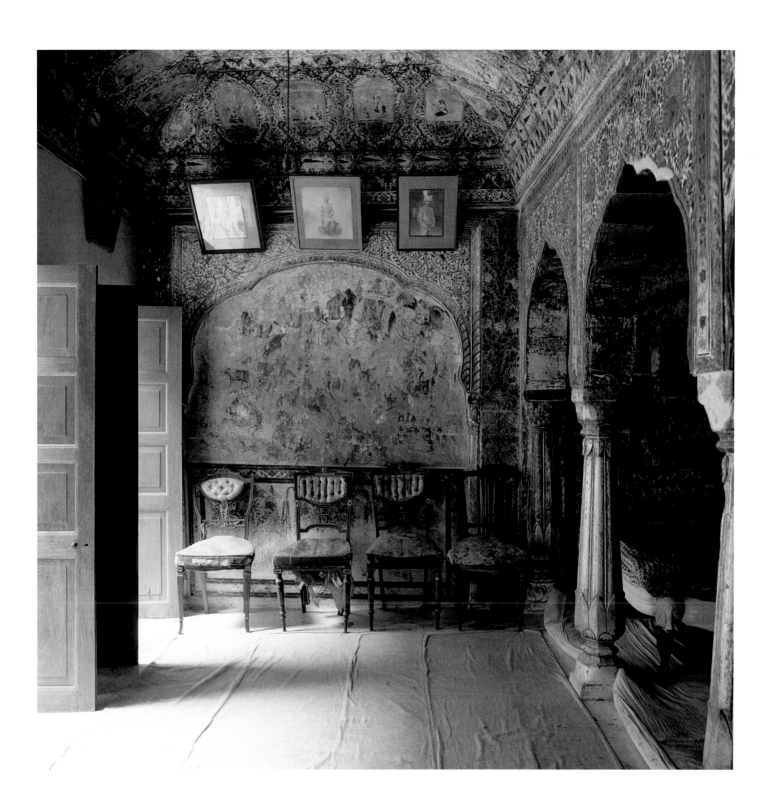

PLATE 74

Shekawati Haveli, Rajasthan, 1982

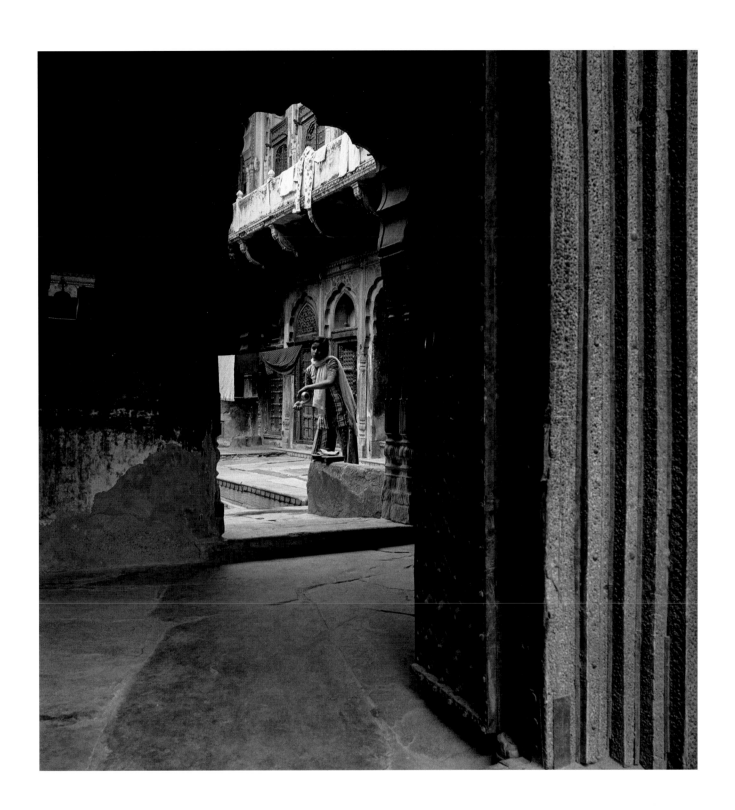

PLATE 75

Girl through an open door, Rajasthan, 1982

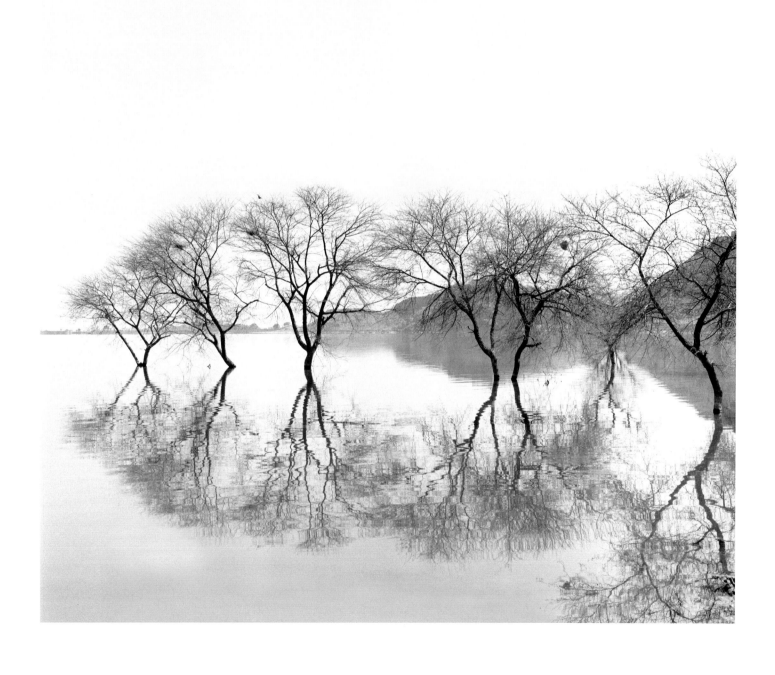

PLATE 76

Reflections in a lake, Rajasthan, 1982

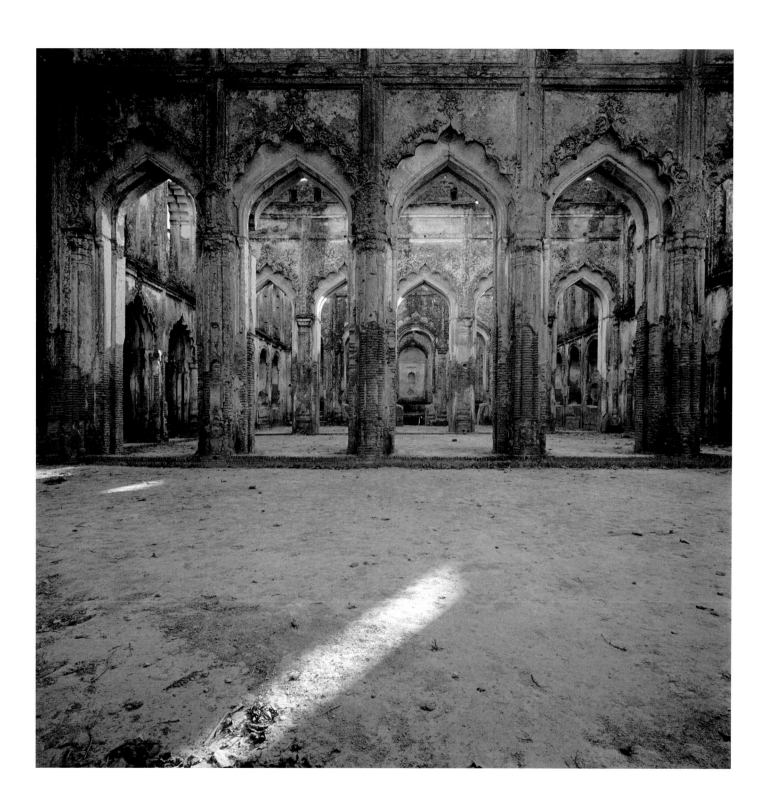

PLATE 77

Ruins of the British Residency, Lucknow, 1977

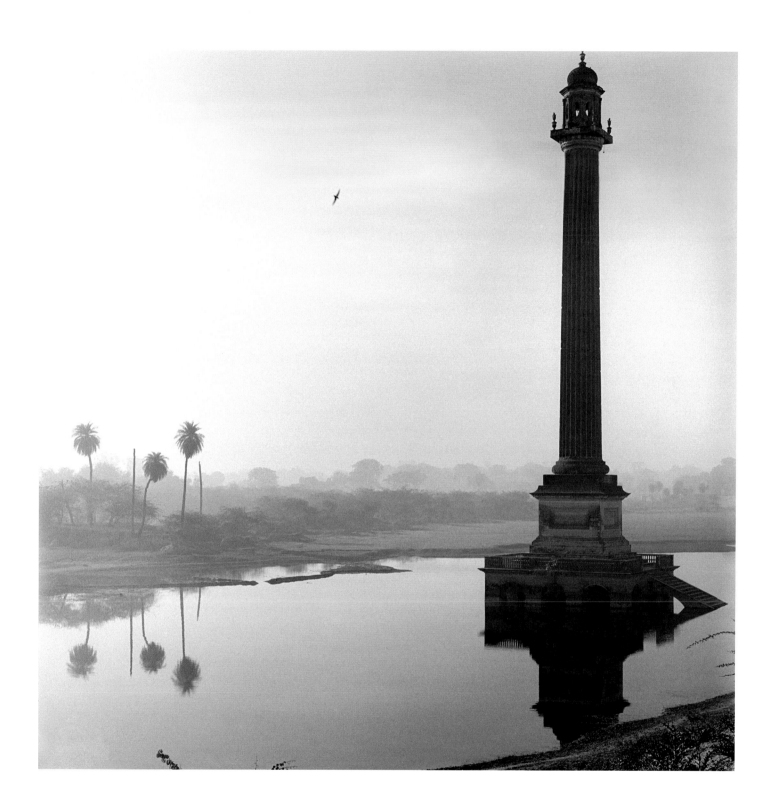

PLATE 78

Column at La Martinière, Lucknow, 1977

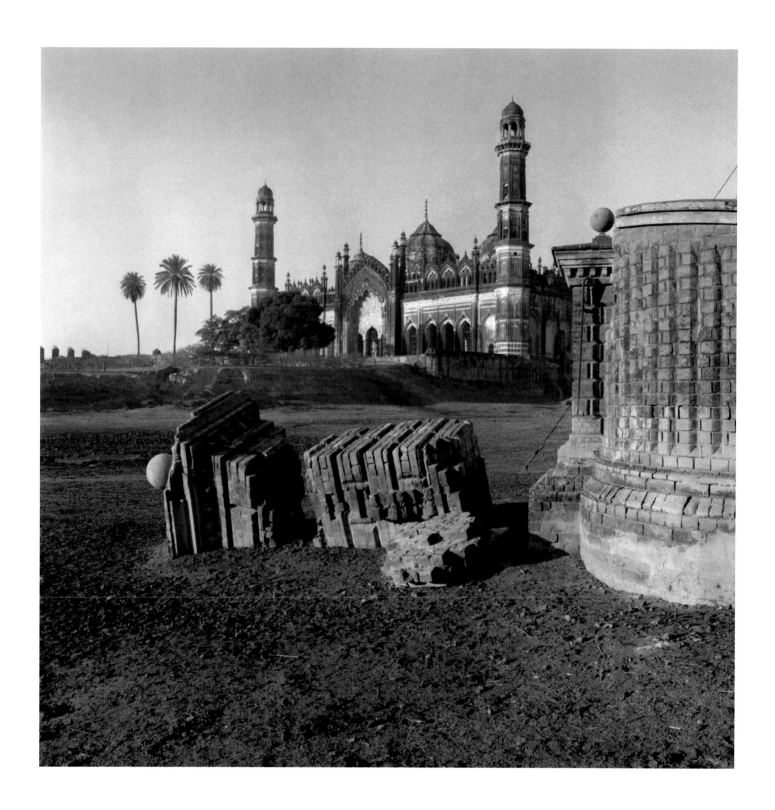

PLATE 79

Ruins by the Jama Masjid, Lucknow, 1977

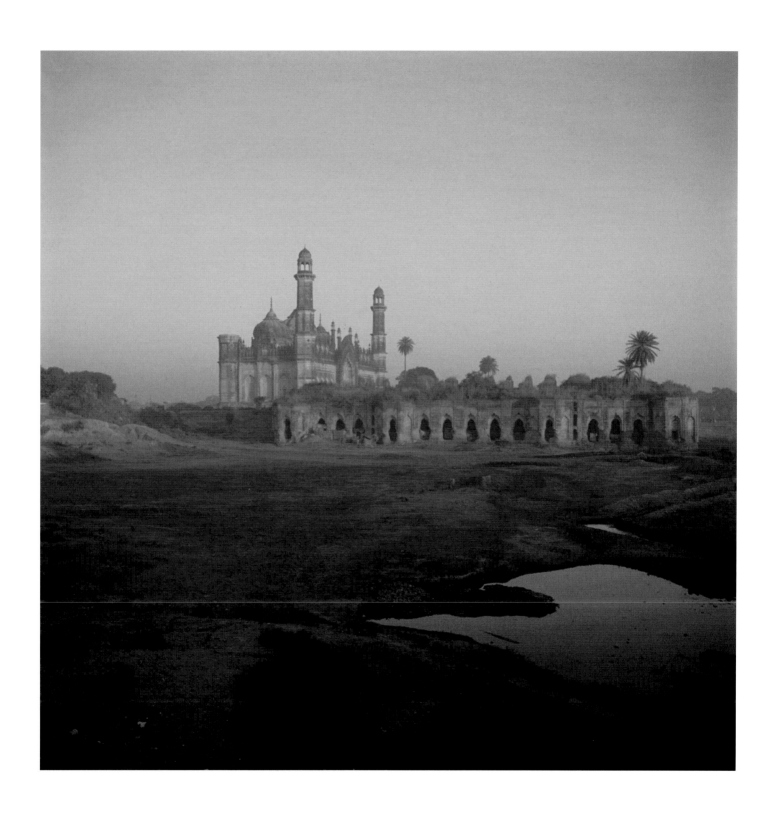

PLATE 80

Jama Masjid, Lucknow, 1977

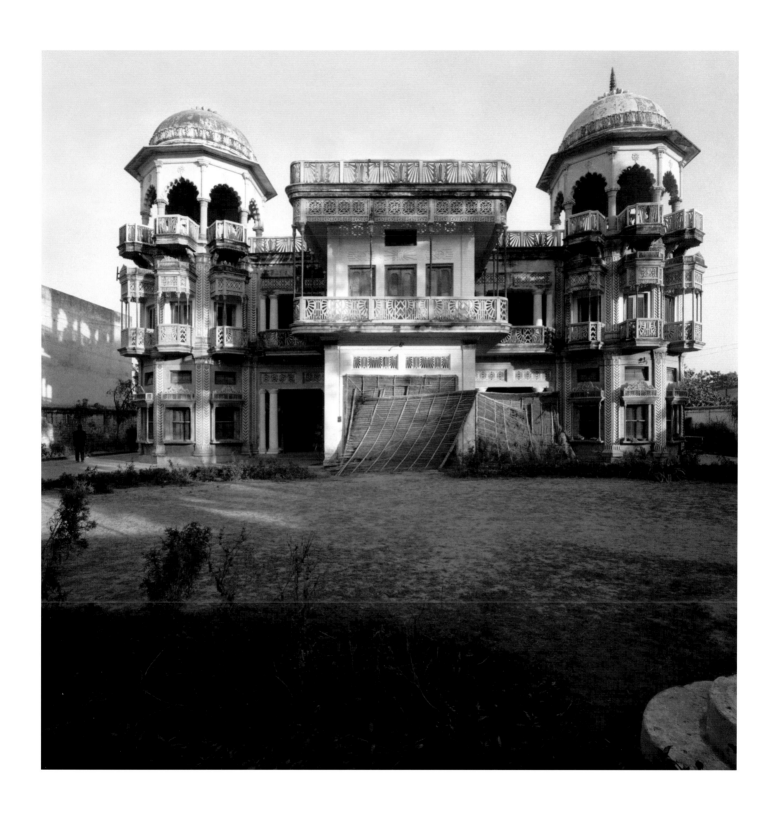

PLATE 81

A grand residence, Lucknow, 1977

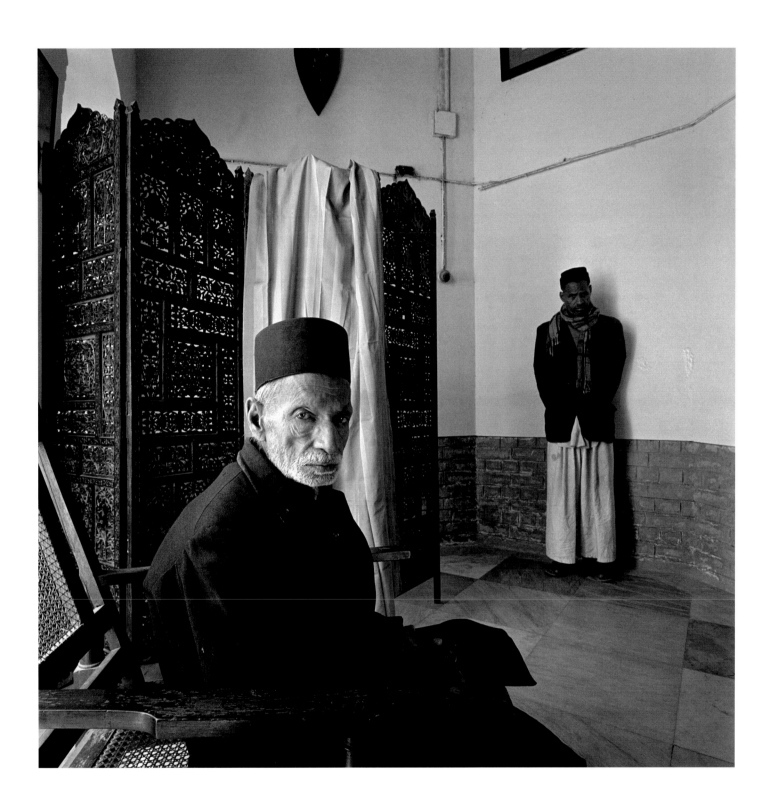

PLATE 82

Chowkidar (watchman), Lucknow, 1977

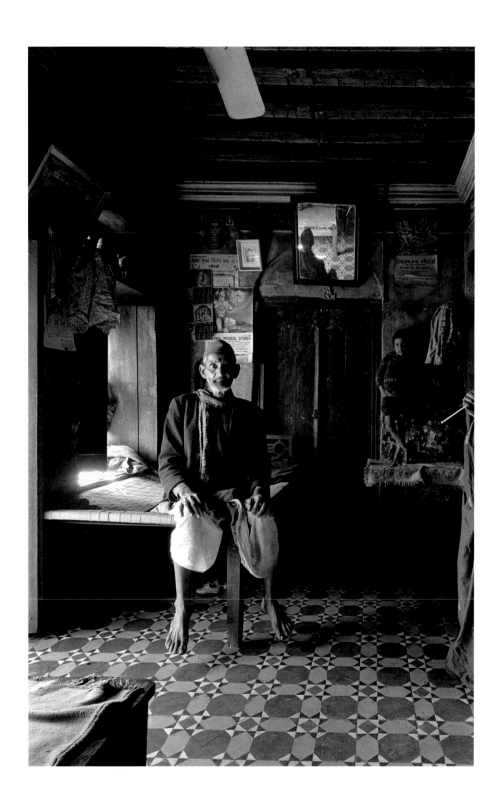

PLATE 83

A man and his grandson, Lucknow, 1977

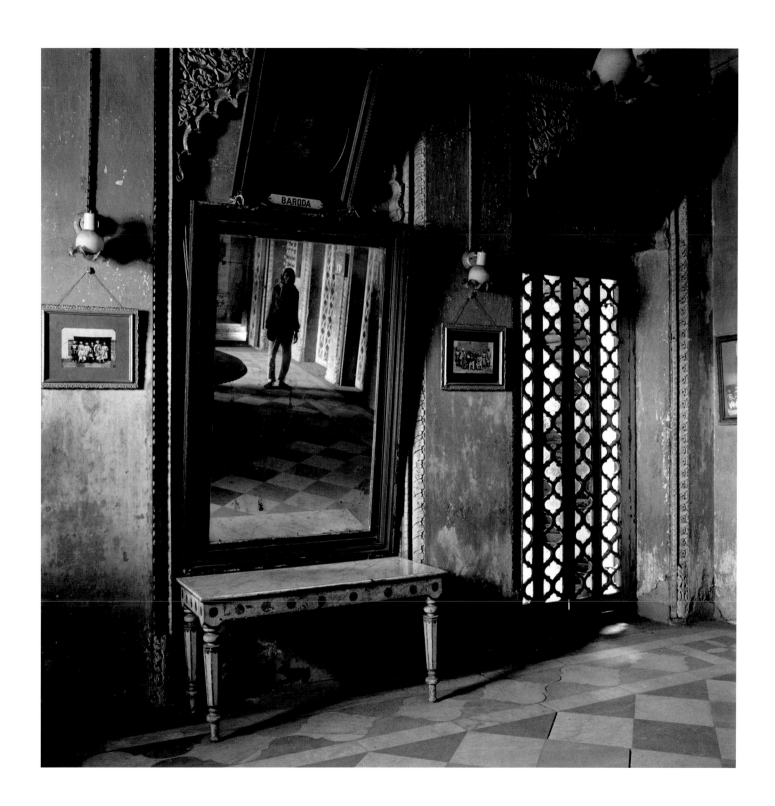

PLATE 84

Interior, Ramnagar Fort, Benares, 2001

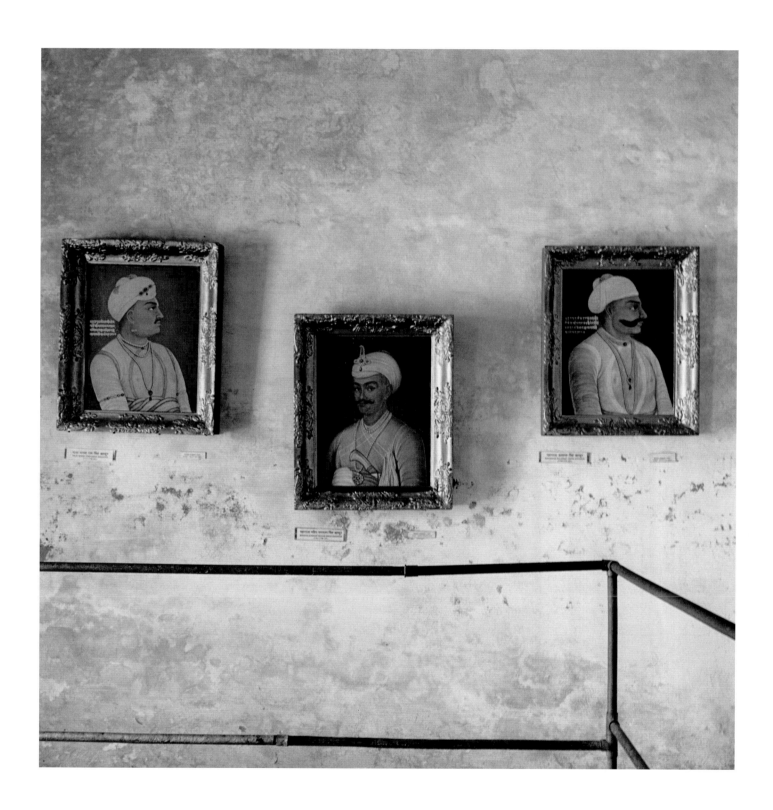

PLATE 85

Ramnagar portraits, 2001

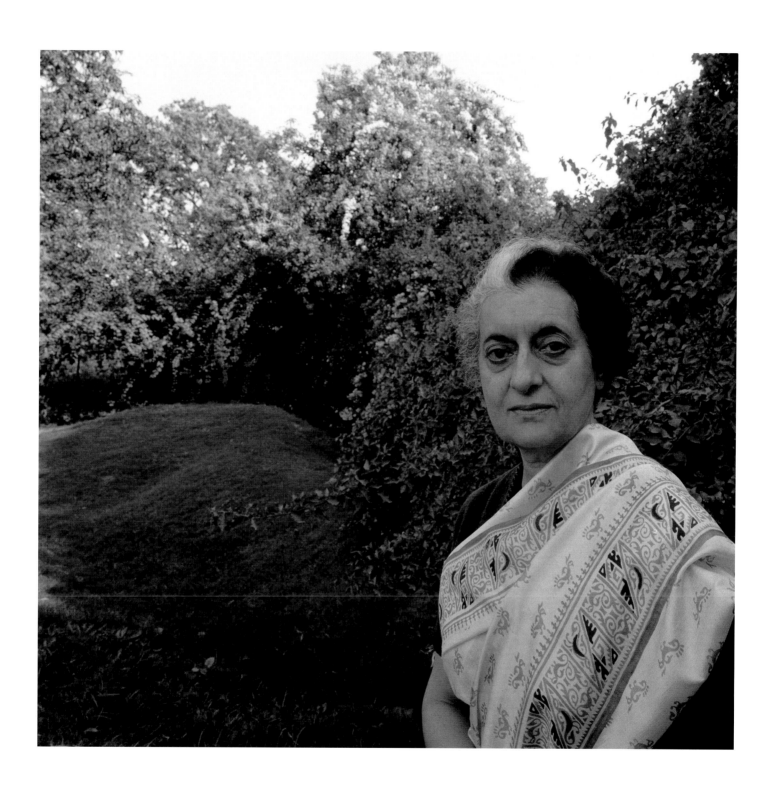

PLATE 86

Indira Gandhi, 1976

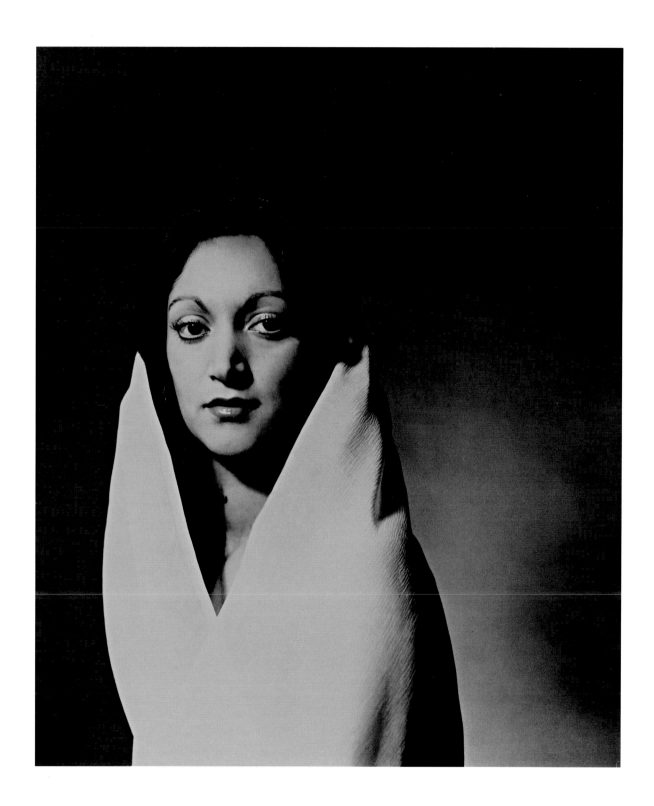

PLATE 87

Bina Shivdasani, 1978

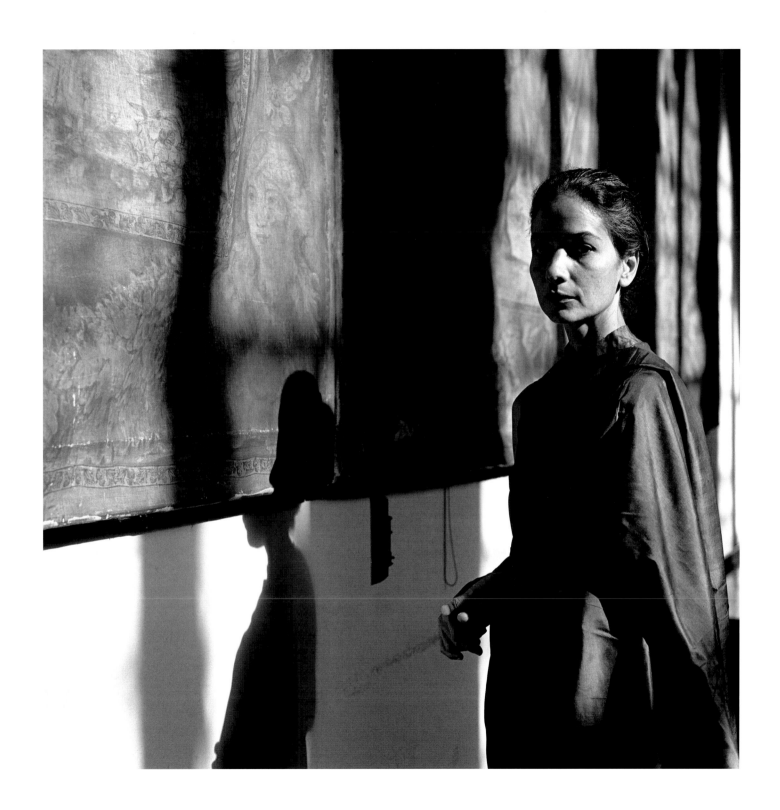

PLATE 88

Anita Desai, 1978

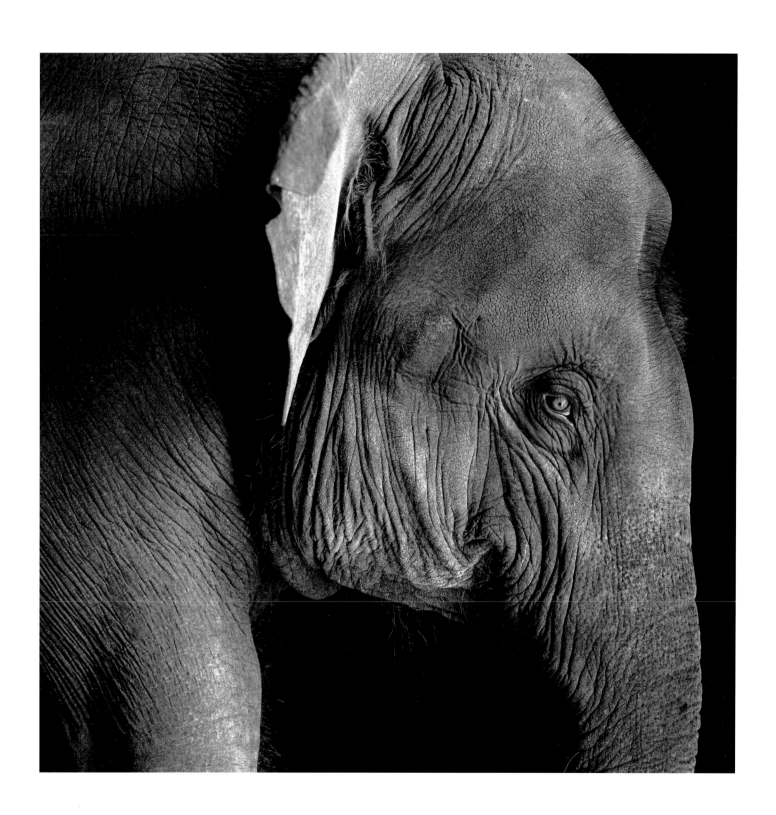

PLATE 89

A young elephant, 1993

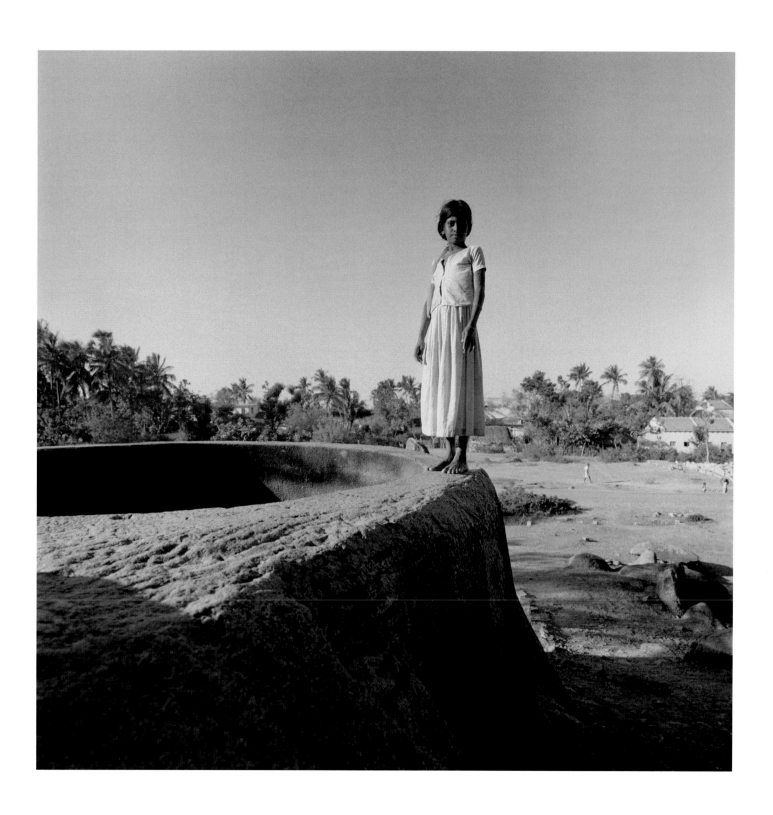

PLATE 90

Girl in Mahabalipuram, 1976

Editor's Note

Since its independence in 1947 and continuing to the present day, India's state borders have been redrawn, its capitals have been reorganised, and the names and spellings of several cities have been modified. The initial changes were the result of the merging of the princely states and their accession to the new Indian government (e.g., Rampur, Benares and Tehri Garwal merged to form Uttar Pradesh). Following this, the States Reorganisation Act of 1956 began reorganising India's territories along linguistic lines – leading to the changing names of states (e.g., Travancore-Cochin and Malabar merged to form Kerala). The renaming of cities and towns, however, has been largely prompted by a desire to either reflect a more accurate phonetic transliteration of their local name (e.g., Calcutta to Kolkata), correct inconsistently Anglicised spellings determined by the British administration (e.g., Cawnpore to Kanpur), or as attempts to replace associations and identities of a colonial past with ostensibly more indigenous references (e.g., Madras to Chennai).

In the essays and image captions in this book, the earlier Anglicised versions of place names have been retained, as deemed appropriate to their context, or as they are still often in colloquial use and more internationally recognised. As such, present-day Mumbai is referred to as Bombay, Chennai as Madras, Kolkata as Calcutta, Varanasi as Benares, Vadodara as Baroda, Odisha as Orissa and the former princely state of Awadh as Oudh.

In Derry Moore's introductory essay, "The Photographer in India", originally published in *Evening Ragas* (John Murray, 1997), while these older place names have been retained for the same reasons as above, the Anglicised spellings, Parsee and Mogul, have been modified here to their present-day usage, Parsi and Mughal, as this is how they are universally referred to today.

Acknowledgements

There are so many people to whom I owe thanks that I fear many names will have escaped my memory. I hope these omissions will be forgiven. Moreover, many of the people listed below are sadly no longer with us.

I would particularly like to thank Princess Esra Jah, who first invited me to Hyderabad and extended such generous hospitality to me there; Mrs Sunita Pitamber, to whom I owe my first visit to Bombay in 1976; Mr and Mrs Bob Wright, who put me up – and put up with me – at the Tollygunge Club in Calcutta on many occasions; likewise Mr and Mrs Naresh Kumar for all their kindness in Calcutta; Maharajkumar Swaroop Bhanj Deo of Mayurbhanj; Mr Ajit Singh; the Earl and Countess of Harewood, who furnished me with some invaluable introductions on my first visit, in particular to Mr and Mrs T. S. Sadasivam to whom I owe especial thanks; Mr Jamshed Bhabha; Nawab Habeeb Jung; Nawab Zainul Abedin Khan; Her Highness Annabella Singh of Mewar; Mrs Camellia Panjabi; Mr J. R. D. Tata; Mr Farid Faridi; Mrs J. C. Ghosh; Mani Sankar Mukherjee; Satyajit Ray; and Maharajkumari Nandini Devi.

My thanks also to Abhishek Poddar and Nathaniel Gaskell of Tasveer who have put this book together, and to Andrew Hansen and Prestel Publishing, who published it.

© Prestel Verlag, Munich · London · New York, 2017
A member of Verlagsgruppe Random House GmbH
Neumarkter Straße 28 · 81673 Munich

© for texts: the Authors, 2017
© for images: Derry Moore, 2017

Cover photograph: Column at La Martinière, Lucknow, 1977
Back cover photograph: Girl in Mahabalipuram, 1976

The right of the author to be identified as the author of this work
has been asserted in accordance with the Copyright, Designs and
Patents Act 1988.

Prestel Publishing Ltd.
14–17 Wells Street
London W1T 3PD

Prestel Publishing
900 Broadway, Suite 603
New York, NY 10003

www.prestel.com

This book accompanies an exhibition produced by the
Tasveer Gallery.

Tasveer
Sua House
26/1 Kasturba Cross Road
Bangalore 560 001

www.tasveerarts.com

Library of Congress Control Number is available; British Library
Cataloguing-in-Publication Data: a catalogue record for this book
is available from the British Library

Editor: Nathaniel Gaskell
Design and layout: Moksha Carambiah
Picture research: Shilpa Vijayakrishnan
Production management: Corinna Pickart
Printing and binding: Longo AG, Bolzano
Paper: Condat matt Périgord

MIX
Paper from
responsible sources
FSC® C023164
www.fsc.org

Verlagsgruppe Random House FSC® N001967

Printed in Italy

ISBN 978-3-7913-8332-3